WATERCOLORS

by J. M. Parramon

Published by
H.P. Books
P.O. Box 5367
Tucson, AZ 85703
602/888-2150

ISBN: 0-89586-074-0
Library of Congress Catalog
Number: 80-82381

Publisher: Bill Fisher
Editorial Director: Jonathan Latimer
Editor: Randy Summerlin
Editorial Advisor: Donna Hoffman
Art Director: Don Burton
Design & Assembly: Donna Hoffman
Typography: Cindy Coatsworth, Joanne Nociti

Published in Great Britain by
Fountain Press
Argus Books Ltd.

Third Edition in English, 1977

Original title in Spanish
Cómo Pintar a la Acuarela
© 1968 Jose M.a Parramon Vilasalo

Deposito Legal B. 5778-1977
Numero de Registro Editorial 785

CONTENTS

ADVISER: GUILLERMO FRESQUET BARDINA

The Parramon Instituto is pleased to acknowledge the assistance of Guillermo Fresquet, who was joint author of the text and painted most of the illustrations in this book.

Guillermo Fresquet's mastery of watercolor has won him numerous prizes, including first prize in the Llavaneras landscape exhibition, first medal from the Cataluña Watercolorists' Society, special prize at the 1st Montblanche Biennial, first prize at the Deputation of Tarragona Province, Society's Medal at the Second Montblanche Biennial, first medal from the Cataluña Watercolorists' Society, and first prize from the Barcelona Municipal Government.

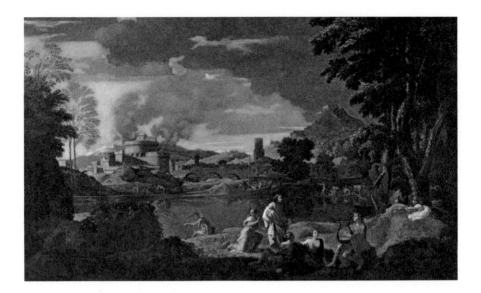

During the Neoclassical movement in the 18th century, two excellent interpreters of landscapes with classical ruins were Nicolas Poussin, represented above by *Orpheus and Eurydice;* and Claude Lorrain, whose *Cephalus and Procreus* is shown below.

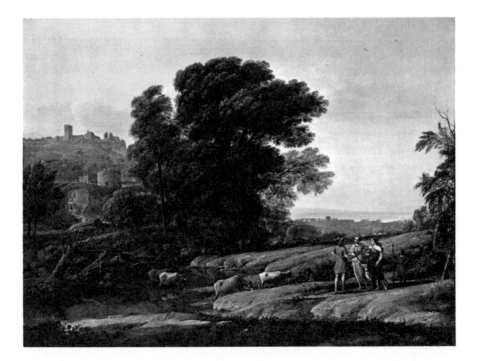

WATERCOLORS 1

If we define watercolor as any pigment diluted with water and applied to a surface, we can say it is the oldest painting medium known to man. The earliest watercolors are the cave drawings of prehistoric man.

In the history of Western art, one of the first methods of water-color painting used widely was *fresco* painting. The colors for fresco are created by mixing an opaque watercolor with plaster and lime and applying it to a wet surface. The discovery of oil painting, and the brilliant colors oils can produce, led to a decline of interest in fresco, and watercolor became a medium used primarily for preliminary sketches and studies.

But interest in watercolors never completely died out. During the Renaissance, when there was a great deal of experimentation, a method of coloring a sketch with transparent colors, similar to our watercolors, was developed. A drawing was made with a pen and one color, usually black. A second color, usually sepia, was diluted with water and applied with a brush to emphasize the contours of objects. Modern watercolor techniques probably derive from this type of sketch, called *monochrome aquarelles.*

During the 18th century it became fashionable in England to travel. No gentleman was considered fully educated until he had made the "Grand Tour" of Europe. The obligatory route passed through France, Switzerland and Italy with Rome as its final destination. In London society it was vital to have seen the Coliseum, the Arch of Titus or the Baths of Caracalla.

This discovery of Rome by the English had a considerable influence on the taste of the upper classes. Indeed, the whole of Europe looked toward Rome and Athens for artistic inspiration. Every sphere

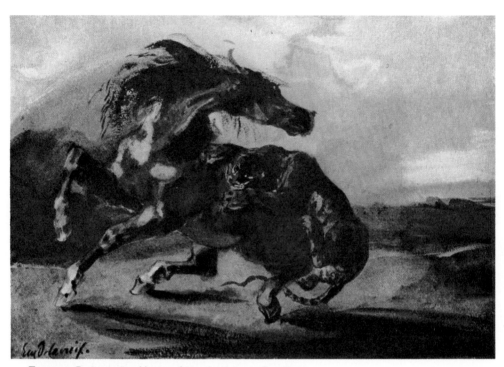

Eugene Delacroix, *Horse Attacked by a Panther.*

of art, painting, sculpture and architecture, imitated the forms of Greek and Greco-Roman art. It was the period of the artistic movement known as *Neoclassicism.*

But English taste was being shaped by other influences as well. For instance, when passing through Paris on their way to Italy the English could see the astonishing landscapes of Nicolas Poussin and Claude Lorrain. These were the first artists to take their easels outdoors and paint nature as it is. But, in keeping with the neoclassical style, their landscapes nearly always included ancient Roman ruins or monuments.

The originality of landscapes painted outdoors, the popularity of classical ruins, and the English love of nature were combined in the experience of visiting Rome. And, typical of travelers today, the English tourist wanted to take away a souvenir of the Eternal City, usually a painting or sketch.

At first these paintings were commissioned from Italian artists. But the demand soon outgrew the supply. So, the English began producing large prints of famous scenes in Rome. These prints were made in a single color, black, from magnificent copper engravings. It soon became fashionable throughout England to own these prints.

Then someone began painting these reproductions by hand with transparent colored washes. Hand coloring became increasingly popular until the prints seemed to be painted rather than drawn. To improve production, the prints were standardized, using a maximum of five colors. Eventually someone painted a picture using the full range of transparent colors without basing it upon a black print. Instead he painted directly upon a pencil sketch, and watercolor painting was born.

Watercolor painting quickly found a home in England and the great age of watercolor landscapes began. Artists such as Paul Sandby, John Cozens, John Constable, J.M. William Turner, Peter de Wint and Samuel Colman made watercolor the most popular method of painting in England.

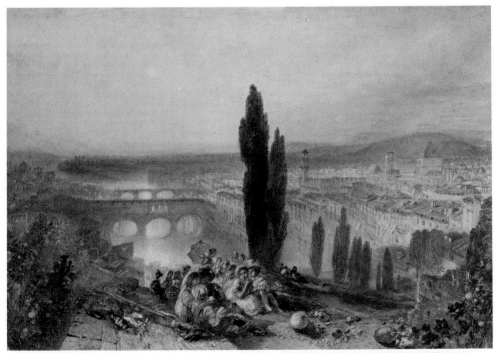

A watercolor by J. M. William Turner.

By the end of the 19th century watercolor painting fell out of fashion. But in the second decade of this century, there was a revival of interest in watercolors and it was again raised to a leading position as a special technique. Not only amateurs, but 20th century masters such as Henri Matisse, Pablo Picasso, Paul Klee, Raoul Dufy and Andrew Wyeth have made extensive use of watercolor both as studies for oil paintings and as finished works.

Watercolor painting is spontaneous and fresh. It can be used to capture a passing moment or an instant of light. You work fast and actually "draw" on your paper with color. Once you've worked through the exercises in this book, you'll be ready to paint whenever the fancy strikes you. But don't stop with these exercises. The best way to learn to paint or draw is to practice. Paint or draw every chance you get, and learn as much as you can from your experience.

CREATIVITY AND INSPIRATION

The reasons for including some of the exercises in this book may not be apparent immediately. I assure you that they were developed after years of teaching and learning from my students. If you fear that these exercises will dull your creativity, let me point out one thing. Think how much better you will be able to express that creative spirit once you have mastered your materials and techniques. Then you can attempt anything you want and have a good chance of succeeding.

Watercolor is the ideal medium for expressing flashes of inspiration. A view of the ocean, or a forest, a face, a moment of color, any of these can be turned into a complete painting in a matter of hours. I can supply the tools. You can do the rest.

MONOCHROME

Watercolor is painted with transparent washes. Once a color is put on the surface, it cannot be changed. If you put a second color over the first, the result can be muddy. If you try to remove the first color, you will always leave a tint behind. A watercolor in one color is called a *monochrome*, which is sometimes known as a *single-tint drawing*.

Technically, monochrome is characterized by drawing and painting with only one color diluted to various degrees with water. With

Monochromatic painting can produce dramatic results.

the help of the white paper, this produces the tones of the subject through the transparency of the color washes.

In painting, the term *wash* means a layer of transparent color applied either directly on a surface, in this case paper, or onto another color, producing a specific color or strengthening the existing tone.

Wash painting can be done equally well with one watercolor or with India ink diluted with water. When diluted, both are transparent. Black is generally used for monochrome but it is possible to use other dark colors such as dark blue, dark green or sienna. Monochrome in the purest sense of the term does not allow retouching or repainting with white paint.

In watercolor and monochrome the most important element is the white paper itself. It is almost impossible to get a pure white, so

white areas are obtained from the paper by leaving areas blank. This requires careful planning before you begin painting.

Water is used to dilute and weaken the tone of the color to obtain grays and muted colors. When using watercolors, tap water is satisfactory, but with India ink, the water must be distilled or boiled. Watercolors are softer than India ink, so that it is much easier to obtain muted colors and weaker tones with water.

I feel that it is not only advisable, but essential to begin these instructions with practical study of monochrome. This method will teach you how to control your mixture of color, water and the white of the paper to produce the exact tones you want.

When watercolor comes out of the tube, for instance a tube of black watercolor, it is an opaque paste. We have to dilute the black with water to develop it and obtain the range of grays found between the black and the whiteness of the paper. To paint a regular, uniform gray area, a little watercolor must be diluted with a small amount of water until all the watercolor paste is dissolved. The more water, the less color. The more water, the greater the transparency. The more water, the greater the impact of the white paper, the more we notice the whiteness of the paper and, therefore, the lighter the tone of the color applied.

Monochrome is widely employed in commercial art, both for advertisements and for producing illustrations or sketches for brochures, cards or catalogs. It is a widely used medium for preliminary studies, especially for figures and landscapes.

MATERIALS FOR MONOCHROME

First of all, let's look at each of the items you will use in painting a monochrome.

MATERIALS	
Black watercolor or India ink	No. 10 brush
One or two jars of water	Rag
Watercolor palette or	Blotting paper or paper towels
small china plate	Drawing board
Scrap paper for testing colors	Canson paper
No. 6 brush	Pencil

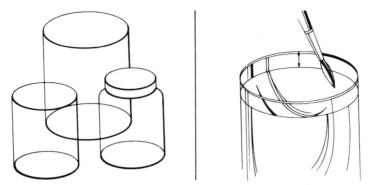

Almost any jar can be used to hold water. Fill your jar to about 3/4 inch from the top. This will leave enough space to press your brush against the edge to remove water.

Jars—Use a glass jar with a wide neck for the water. It should hold a pint or more. Professional artists generally use two jars. One holds clean water for mixing colors and one for cleaning their brushes. When filling a jar, the water level should be about 3/4 inch below the lip so that the *load*, the amount of water taken up by the brush, can be controlled more easily. Sometimes, when touching up or darkening small areas, only a very small amount of water will be required.

Palette—A white enamel butcher's tray or a large china plate is excellent for dissolving the color and preparing washes of the same tone. I do not use what are called palettes, a kind of porcelain saucer with one or more hollows. I find them too small. Instead I use a large plate and squeeze color from the tube on the edge. Then I take what I need for mixing with water in the middle of the plate. It is a matter of choice.

A bowl or a special tray can be used to hold your watercolors. A piece of paper is used to test your colors.

Brushes—Brushes come in various sizes which are indicated by numbers stamped on their handles. They are made of sable or camel hair. Three brushes, No. 2, No. 6 and No. 10, are sufficient for monochrome.

The No. 10 brush is used for the basic wash. Final touches such as outlining and touching up smaller shapes are painted with a finer brush. The same brushes are used for monochrome as for watercolors.

Paper—Monochromes should be painted on good quality drawing paper such as Canson brand. It must be thick enough not to lose its shape when moistened. Very smooth or thickly primed paper with a shiny or satinlike surface cannot be used for monochrome. To prevent disappointment, I recommend you always buy the same brand or grade of paper, once you have found one that is satisfactory. If you are in doubt, before sketching out your subject, test the paper by painting some grays and shaded areas on a small piece. This way you can check the paper's absorption of water and the firmness and consistency of its fiber. Some papers must be stretched before you can paint on them or they will wrinkle. Instructions for stretching are given on the following two pages.

Many professionals, myself included, use a piece of paper of the same type used for the picture for testing tones. We squeeze a little color on one corner and dilute it on the paper to test the color before applying it to the picture.

Rags and blotting paper—As we shall see later, the drying or absorption of the watercolor plays a constant part in balancing and harmonizing tones and producing other effects. You will need a large, clean rag for cleaning and drying your brushes, and a clean piece of blotting paper for removing excess water or color when necessary.

Board—Monochrome can be done on a tilted table or board. It is better to use a board where the angle can be varied as required, but either way, the important thing is that the support must be tilted so you can control the speed that the liquid flows down the paper.

Note the angle of the board's tilt. This will prevent the water from running too fast, and also keep pools from forming.

HOW TO MOUNT AND STRETCH PAPER

When moistened, paper loses its shape and wrinkles. When you paint on thick paper, this defect is hardly visible. However, there may be occasions when you will find the following method for mounting and stretching your paper useful.

MATERIALS	
Drawing paper	1-1/2-inch wide strips of
3/4-inch plywood board	gummed tape or a staple gun

Wet the drawing paper by dipping it in a tub of water or holding it under the tap. It must be thoroughly but not excessively wet. Don't be too hurried, but do not leave the paper in the water for more than three or four minutes. Too much water can damage the priming, fiber and consistency of the paper.

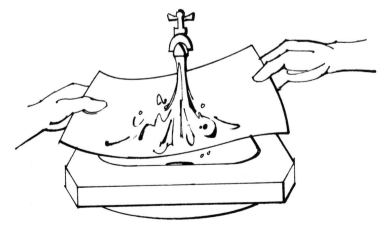

Thoroughly wet your paper under the tap.

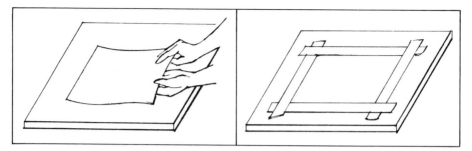

Lay the paper on your board and stretch it a little. Tape or tack the paper to the board and let it dry. Then it is stretched and ready to be painted.

Shake off the surplus water and lay the paper on your plywood board. Make sure the paper is completely flat without wrinkles along the edge. It may help to stretch it a little, pulling it at both sides as shown in the illustration.

The final step is to attach the paper to the board using the strips of gummed tape or staples, framing the paper as shown in the illustration above.

Now you simply wait until the drawing paper dries completely and naturally. Do not try to speed up the drying by placing the paper in the sun or near a heater, although you can use a hair dryer that blows hot air. It is best to dry the paper by laying the board in a horizontal position, on a table for instance. This will help it dry uniformly.

When the paper is completely dry, which takes five or six hours, it will look as taut as a drumhead and it can be painted or moistened as much as you want without producing permanent wrinkles. Keep the paper mounted when you are painting. Once the picture is finished, take it off the board with a razor blade, cutting around the edges. Be sure to allow for the wastage caused by attaching the gummed tape or staples.

The theory on which this simple operation is based can easily be understood. When the paper is wet, it swells up. Then, held by the strips of tape or staples, it contracts when drying, and becomes tight and conditioned against any subsequent loss of shape.

We shall now paint a regular, uniform area of gray.

HOW TO PAINT A UNIFORM GRAY

The importance of this exercise cannot be overstated. It is your first chance to really learn to control your medium and your brush.

If your paper is not already on your board, fasten it to the board with pins or tacks. Use a pencil to trace a 3-1/2 by 4-inch rectangle on the drawing paper. Put some black watercolor on the edge of your palette or plate. Take a No. 10 brush and wet it until it is almost dripping. Put the water from the brush on the edge of the plate. Repeat this several times. Now take a little color on your brush and dip it in the water on the plate. Mix it by moving the brush in circles until all the watercolor is diluted in the water. Do this slowly and carefully, making sure that every particle is dissolved.

Before painting our gray wash we must check the intensity of the tone of the color mixed on the plate.

First load your brush, wipe it on the edge of the plate and paint a patch of color on your test sheet to test this gray. Let the gray dry a moment on the paper so you can judge its intensity. If it suits you, you are ready to paint a uniform gray.

Paint with the board tilted at about 30°. A degree or two won't matter. You can see the correct angle in the illustration on page 13.

Load your brush again with the water from the plate but don't wipe it this time. Bring it to the paper fully loaded, but not dripping. Paint a horizontal stripe about 3/8 inch wide as shown on the next page.

Paint boldly in one stroke from left to right, just as if you were drawing a pencil line. And don't bother about the water accumulating along the lower edge of the stripe.

Now quickly paint another stripe underneath, keeping the color which accumulates along the lower edge flowing.

Keep calm and everything will be all right. Paint another stripe underneath the second one, then another and another.

Keep the beads of color flowing. This enables you to keep painting over a damp surface so that the color does not run and the wash is perfect and uniform.

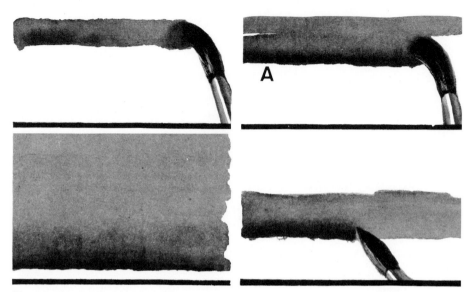

To obtain a uniform gray, paint a series of overlapping stripes, picking up and evenly spreading the watercolor that collects at the lower edge (A) as you go.

Add stripes of gray until you reach the bottom of the paper.

When you reach the bottom, the lower edge of the rectangle you have made will have surplus watercolor which must be removed with your brush or blotting paper.

First, clean your brush by stirring it in clean water until all the color has been removed. Then dry the brush on your rag, wiping off the water and pressing it between your fingers and the rag.

Next, place the tip of the brush on the left end of the bottom edge of the gray and pull it across the gray edge. The brush will act as a sponge, absorbing all or part of the beads of color. You may have to repeat this to absorb more of the liquid. Doing this properly will depend upon how much of the liquid you soak up and whether you wipe your brush well. The aim is to make the tone of this area the same as the rest by absorbing the excess watercolor.

As you can see, the success of this process depends primarily on the tilt of the board and the amount of liquid in the brush. The lower the angle of the board, the less watercolor will accumulate on the bottom. Remember, you are trying to cover the area evenly without edges.

When the tone of the gray is very dark, it is not advisable to wash the brush when using it as a sponge. It is better to dry it or wipe it on your rag without washing it, to avoid the danger of changing and lightening the tone.

One important factor which can be deduced from this exercise, which I think must be emphasized, is that *you usually paint from top to bottom* in monochrome and watercolors.

Also, remember that *the brushstrokes are generally vertical* in monochrome and watercolors.

Bear this in mind. When painting the gray area, we said that the strokes should be horizontal, moving the brush from left to right. In this case we used the most effective, rapid and safe method for painting large gray areas. But this could obviously have been done by a series of diagonal or vertical strokes. The vertical movement is most commonly used by professional painters for painting small and medium-sized areas, for blending and merging. This is because vertical brush strokes follow the angle of the board, and are the most sensible way of obtaining and retaining the accumulation of watercolor which provides better harmonization of values and tones.

REMOVING COLOR FROM A RECENTLY PAINTED AREA

Even if you test your color on a separate piece of paper, you will often find it is too light or too dark when you transfer it to the actual drawing or painting.

Try this experiment. Mix some black watercolor and very little water on your plate to make a very dark gray. Load your brush with

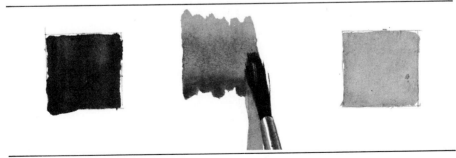

The dried dark gray can be lightened by absorbing color with your brush and clean water.

some of this wash and paint an area about 1-inch square. If you let this dry, the water will evaporate, but the color in the water will remain, producing a dark tone.

Now, paint the same area with the same amount of watercolor on the brush. Then wash the brush in clean water, dry it, wipe it with your rag, and use it as a sponge, absorbing the surplus watercolor. Apply the brush, absorb the color, rewash the brush in clean water, rewipe with the rag, and pass it over the painted area again and again until it is more or less dry. You will have not only removed the water, but also a large amount of the color, automatically weakening the tone, which is now much lighter than before.

This experiment is important. This technique is used for changing, evening out, weakening or lowering a tone, and for correcting a tone immediately after painting it. This is how to go back over your painting, change it, strengthen it or lighten it, operations which are very common in modeling for bringing out the volume of objects.

BREAKS

One of the most common mistakes made when applying washes of watercolor is to break up a gray or shaded area. This problem is so important that it deserves a separate section.

When the area is left half painted, or if only a little liquid is used, or the gray or shaded areas are not painted quickly enough, what we call a *break* occurs. A break is a well-defined change in the tone that forms an edge. A break is always caused by letting the area dry or partially dry before it is finished. A monochrome with several breaks which are not intentional indicates a lack of skill.

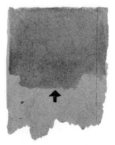

A break in your color, shown with the arrow, is caused by letting an area dry before it is finished. Work swiftly to avoid breaks.

When watercolor is used for painting an area, a break in a gray or shaded area should not occur, no matter how inexperienced you are. But breaks can occur easily when you use India ink diluted with water, even if you are an expert.

PAINTING WITH INDIA INK

Until now we have been practicing painting monochromes using black watercolor. We shall now take advantage of this section on breaks to briefly examine the technique of painting with India ink diluted with water. In practice, the only difference between painting with these two types of color lies in the fact that India ink is far firmer than watercolor. India ink is less flexible, which makes removing surplus color more difficult. It forms breaks with remarkable ease. You must paint quickly and skillfully and be careful not to paint with a tone darker than you want. You cannot go back over it.

Is it worth all this trouble? Yes. India ink can produce remarkable transparency and pure tones. And there are ways to avoid making breaks in the color.

One way to compensate for the lack of fluidity of India ink is to moisten the area with clean water first, so that the color does not form breaks when applied. This method brings us to an important technique in monochromes, known as *wash painting* and for this we leave India ink and return to painting with black watercolor.

WASH PAINTING

Wash painting originally meant painting large areas like a sky in a landscape, but this term can be applied to painting any large area which contains few variations in tone, such as shaded areas with very small contrast or wide areas of flat tones. In these cases the artist employs the following method for moistening the area with clean water first.

The area to be made gray is outlined in soft pencil, an HB or B grade is fine. The area is then moistened with clean water, using a brush or small sponge. It is very important that the water is spread evenly, with the brushloads of clean water being measured and distributed to produce a uniform moist coat. Avoid excessive moisture from blobs of water. The area is then painted with the prepared wash, using the normal method for painting an even gray.

HOW TO PAINT A SHADED AREA

There are three stages in painting a shaded area with a wash.

- Paint first with the darkest tone.
- Spread and dilute this tone with clean water.
- Blend it with a dry brush.

We shall see how this is done in practice, illustrating the method with the following figures.

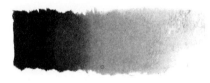

Imagine a wide shaded area in the form of a horizontal strip ranging from black to white, as shown here. This is the effect we are aiming for.

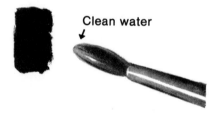

Clean water

First, paint with the darkest tone, beginning with a black patch. As quickly as possible, clean your brush, washing it in clean water. Then rapidly moisten the entire area over which the paint is to be laid, working toward the edge of the black patch. You can even use a second brush if you don't want to clean the first.

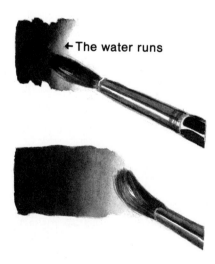

← The water runs

Work fast until you reach the edge of the black patch. It is important that this patch is still wet so that you can dilute it with the water from the moistened area. Spread it with quick vertical brushstrokes but stop before reaching halfway along the moistened area!

Clean your brush again. Dry it and wipe it on the rag, take it halfway along the moistened area, reducing the water and color in this area.

Clean the brush again. Wipe it and continue spreading the color toward the end of the moistened area which is still white. Touch it up and blend the area now shaded.

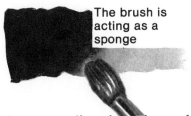
The brush is acting as a sponge

It is a matter of adding and subtracting, spreading the color and weakening it, adding water and drying it. You can continue this process as long as the paper remains moist, which will prevent breaks, and the dark sections are blended into the light sections.

It is always possible to add and strengthen a color, but it is difficult to go back over it all, changing the areas painted black or gray into white. This brings us to another feature of wash painting: *there is no white paint.*

LARGE WHITE AREAS MUST BE MARKED OUT IN ADVANCE

Because we cannot paint large areas with a white color, we must use the paper to make white areas. White areas must be marked out before you start painting.

But, if you make a mistake, it is sometimes possible to obtain a very pale gray, using a method similar to that described when we were explaining how to lower a tone by absorbing the water and color in a specific area.

REMOVING COLOR TO PRODUCE WHITE

Imagine you painted an area some time ago with a very dark gray or black and now it is completely dry. Suppose that you want a small shape in a lighter tone in this area, a star for example. You won't be able to produce a pure white because some of the paint will remain on the paper no matter what you do. But you can make your star out of a very light gray.

Load your brush with clean water and make the area in question very wet by placing a bead of water on the spot to be lightened.

Place a bead of water on the spot to be lightened.

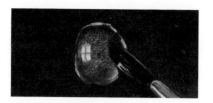

Work it in gently.

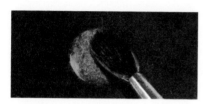

Pick up water with your brush.

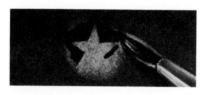

Repaint the edges.

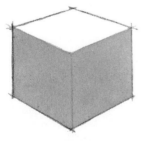

First paint one tone. Let it dry.

Leave the water there for several minutes, long enough to moisten and loosen the color under it.

Now apply your brush, trying to dilute the color with the water formed over it. This takes time and patience. Stroke it gently with the brush so that the color is loosened and diluted by the water. Do not scrub the area or you will destroy the fibers of the paper.

When you think the color has dissolved, clean your brush again, dry it and wipe it with your rag. Absorb the diluted color with your brush. Clean the brush again, absorb more color, and so on until the area is practically dry. This will produce a lighter tone than the surrounding area.

All you need to do now is to touch up the edges to form the shape of your star, and the job is finished.

SUPERIMPOSING TONES OR WASHES

When painting with washes or watercolors, it is customary to superimpose tones, intensifying color values, adapting the painted shape and creating contrasts. Think of the artist as painting in increasing levels, applying one wash over another. For example, to produce the shape and volume of a cube, the correct method is to

first paint the entire shadowed area in one tone, a light gray for instance. Wait for it to dry and then apply a new wash over the darker plane.

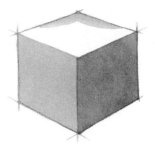

Give volume by adding gray in upper corner.

To finish the picture, paint a narrow strip of gray on the farthest corner of the upper surface. Then quickly shade it while it is still wet with your brush and clear water. Dilute the original strip with water, blending it by absorbing water until you have the proper tones.

When painting one tone over another, the only thing to remember is that the first must be completely dry. The second wash must also be applied rapidly so as not to spoil or disturb the first.

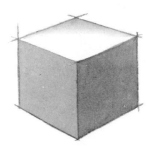

Blend and shape to make shadows look real. Darken the appropriate area.

THE ESSENTIAL FEATURE OF GOOD MONOCHROME

In explaining how tones are superimposed and saying that an artist paints in increasing levels, we may have given you the idea that a monochrome is made by superimposing many washes of color, increasing the tone slowly, wash after wash, until the required intensity is produced. That is not true! A good monochrome is quite the opposite. The essential feature of good monochrome is to *paint the required tones immediately with as few washes as possible.*

Admittedly, that is not easy. But that's where the challenge lies: with your ability to accept the risk and hit the mark on the first or second shot. This produces a genuinely artistic and skillful work, a fresh, spontaneous and assured monochrome.

To acquire this skill and assurance you should paint many monochromes, practicing and learning. Use the techniques in these paragraphs and in the practical exercises that follow. But genuine

knowledge will only be gained by painting dozens of monochromes, practicing the technique and skill of monochrome over and over.

EXERCISES IN MONOCHROME

In the shapes and models given here we have tried to include all the technical difficulties which may occur in painting a monochrome. They may seem simple, but when you can do them perfectly, you will be capable of dealing with any subject, no matter how complicated it may be. In practice, monochrome landscapes, still lifes and figures are a combination of shapes depicted in flat gray and shaded areas, cylinders and spheres. So treat these exercises with the respect they deserve. When practicing them, keep in mind that they are essential and the final stage of your apprenticeship.

MONOCHROME OF A BOOK

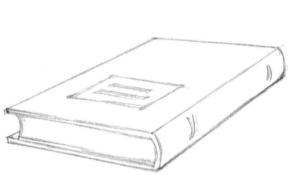

Make an accurate sketch.

First you need to draw a good outline, copying an actual book if you wish, and, if necessary, using a ruler and square. Work out the line of the horizon and the lines of perspective. Try to produce a simple but completely accurate sketch.

Paint planes *A,* the edge of the book, and *B,* the spine, with a flat gray wash as shown at the top left on the facing page. Be careful not to go over the outline. Keep the small area of light at the point marked *a.* Also paint the smooth shading at the upper edge of the spine marked *b,* simply by cleaning your brush. Moisten the shaded area while the gray wash is still wet, then soak it up and blend it with more brushstrokes.

The next stage is to paint the cover *C* as shown on the right at the top of the next page. Leave the square for the title white.

When the entire plane is moistened, place a stroke of gray wash at the farthest corner, more or less as marked by the dotted line.

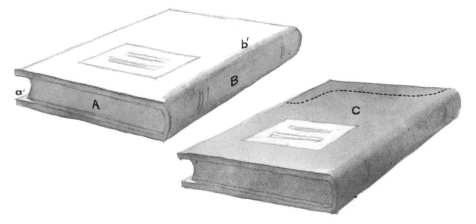

Paint the edges and spine. Then paint the cover. Then paint the edge of the farthest corner and blend the shading.

Then clean your brush and spread this gray wash downward, shading it. Clean your brush again, dry it and wipe it on your rag and soak up the water and color in the nearest section which has to be lighter. Blend the shading.

Now darken edges *a'* and *b'* of the cover and the spine, *c'*, by adding another wash which produces a darker tone as shown below. Using the same gray, paint the shadow, shading it along its outer edges.

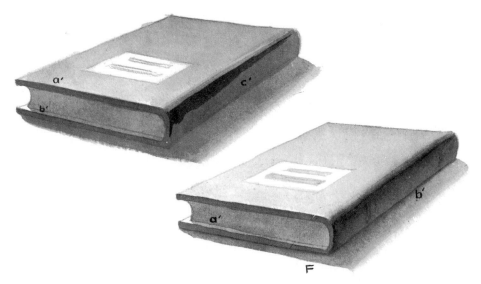

The last stage is to add the shadows and blend them. This gives you the finished monochrome shown at the right.

Finally, add the shading which gives the peak shadow on the spine, the darkest part of that shadow. To see how, compare the figure on the left on the preceding page with the finished picture on the right. First you have to paint a dark strip as shown in the figure on the left. Then, while it is still wet, shade this strip with a clean, almost dry brush, soaking up the color and blending it until you get the picture shown on the right.

There are two important points to remember.

As I said before, for this or any other similar picture to be successful, the previous wash must be allowed to dry before adding another.

In this and similar cases, when the shading is unsatisfactory or badly blended, it is best to wait until it is dry and then repeat the operation.

To complete this exercise, darken the area where the spine meets the shadow, marked b' on the last illustration, with a dark line. Paint the title of the book with a single brushstroke and soften the edge of the pages of the book to bring out the plane formed by the cover.

MONOCHROME OF A CYLINDER AND A CUBE

As before, carefully draw an outline sketch to produce the perspective effects and shadows in the picture on the next page.

Look at the first example. Paint sides B and C of the cube with a gray wash, spreading the gray to the shadow cast by the cube. Soften the edges of this shadow.

Now moisten the highlighted side D of the cylinder with clean water using your brush. When this area is wet, paint the gray shadow of the cylinder. Shade this gray to the edge of the light area. You may find it easier if you turn the paper and work this shading with horizontal strokes.

Darken surface C of the cube, forming beads of wash along the upper left edge as shown with the arrow in the figure at the upper right. This area should be shaded darker than the opposite one. Paint the shadow cast by the cylinder on the ground behind the cube. Paint the smooth shading on surface A of the cube, working from the farthest edge and shading toward the front.

Paint the smooth shading on the top of the cylinder, marked *E* as shown in the right hand figure below.

Finally, paint the shading for the cylinder's shadow to produce the finished picture shown below. Begin by moistening highlight *D* with clean water and apply a dark tone along the edge, shading toward

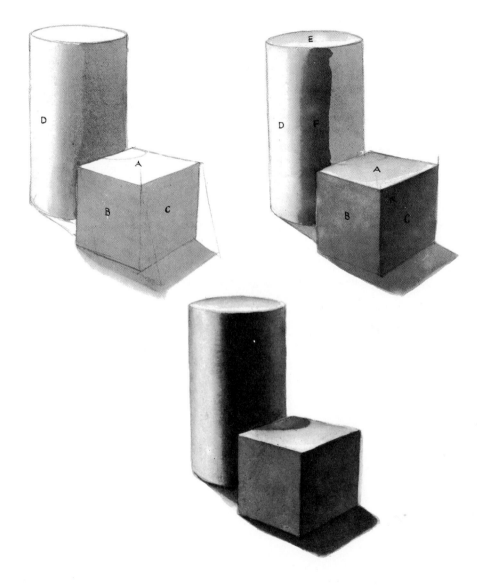

Begin with a light shading of the darker areas. Remember, you can darken your gray much more easily than you can lighten it. Add and blend until you reach the finished picture shown here.

the right and spreading the tone toward the area in shadow. This should be done while strip *F* is wet, working quickly to prevent breaks. Brush from top to bottom, turning the paper so that you are painting in a horizontal direction. Compare the shading of this section in the finished picture and the figure at the upper right.

Finish the picture by painting the shadow cast by the cylinder on the cube.

MONOCHROME OF A SPHERE

First draw a sphere in pencil. Use a compass if you like. Work out and draw in the shadow it casts. Mark the section of the sphere where the light would be brightest with a small circle, marked *G* here. Throughout the exercise this area will not be moistened or painted.

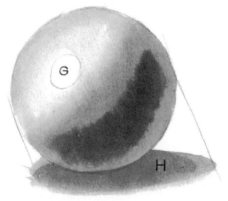

Shade your sphere but leave area G untouched.

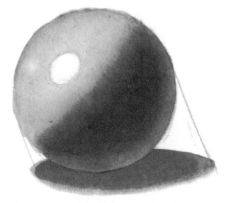

Blend the shadow beneath the sphere.

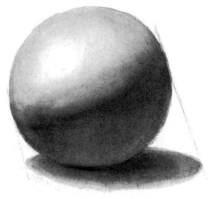

Finish by blending all the shading to give your sphere volume.

28

Begin by painting the shadowed section of the sphere as shown in the top figure on the preceding page. First moisten the illuminated section, without moistening highlight G, with a brush and clean water. Tint all the illuminated area with the same gray used for making the shadow.

Let this first wash dry completely. Then moisten the shadowed area with a brush and a little clean water. The water will pick up some color which you should shade into the illuminated area. Paint a dark gray patch as shown in the top figure.

If the area is sufficiently and evenly moist, the patch will spread on its own, avoiding the danger of breaks. Give it the tone of the shadow cast by the sphere, marked H in the top figure. Now work on the patch, shading it with an almost dry brush which need not be cleaned. You should get an effect like the shadow in the lower left figure.

Wait until it dries before darkening. If the shading is not perfect, remember what I said earlier about waiting until it is dry before trying again.

Work with the shading until you get the result shown in the right figure. The section formed by the reflected light has to be painted by soaking up water and color. The circular shading of the illuminated area has to be obtained by painting a narrow strip along the edge of the sphere and shading it inward to the highlight.

MONOCHROME OF A HORSE'S HEAD

We shall now try to produce a monochrome of a horse's head using the figure on page 31 as our model. Your success in this exercise depends on having practiced the previous exercises. The technique employed and the difficulties encountered are virtually the same.

I will give only general instructions because the knowledge you have already acquired will be enough to produce a satisfactory result.

INITIAL DRAWING

As always, begin with a very careful sketch. Remember that the final result depends to a great extent upon an accurate drawing.

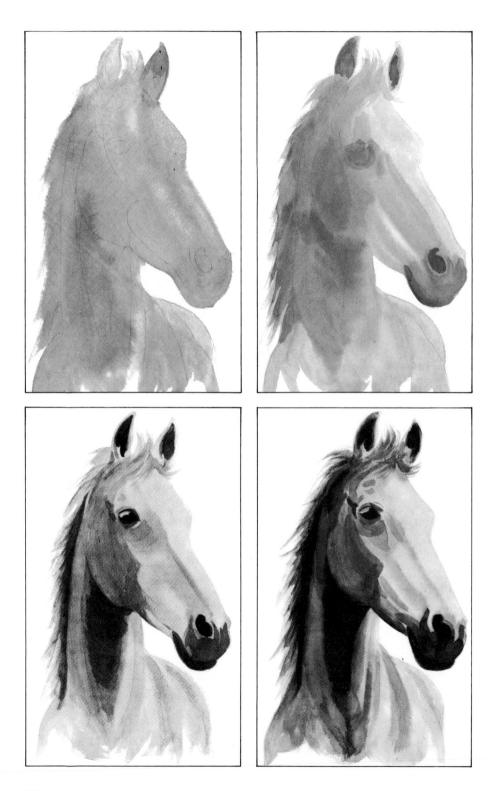

FIRST STAGE:
INITIAL TONING

Wet the entire drawing of the horse's head using a brush and clean water. Then paint a basic gray tone over it. This wash is intended to show as many of the model's lightest tones as possible.

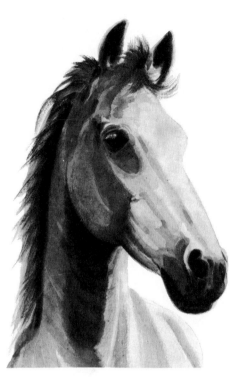

Without waiting for the previous wash to dry, apply another wash, picking out the darkest values or tones of the model in advance, as shown in the top two figures on page 30.

Now wait until these washes are completely dry. Then work over the subject, thoroughly shading until you obtain the result shown in the lower left figure.

SECOND STAGE:
FINAL TONING

Decide which is best for your painting, working on a dry or wet surface, and apply all you have learned about gray and shaded areas. Intensify the tonality until you reach the stage shown in the bottom right hand figure on page 30.

FINAL TOUCHES

Look at the painting above. This is the finished work. Remember that it was produced by patient and thoughtful work, done without haste, and by constant comparison between the painting and the model.

2 MATERIALS FOR WATERCOLORS

Brushes
Paints
Paper
Supports

Watercolor painting is the same as monochrome except that you work with many colors. We can say that *watercolor is a type of painting in which colors have been diluted to varying degrees with water.* It is applied to white paper, keeping the tones transparent. This excludes use of thick coats.

BRUSHES

Brushes used for watercolors are made of sable or soft camel hair, or stiff hog's bristle. Sable is preferred but is much more expensive than camel. A good watercolor brush must have the following characteristics:

- Bristles must be fine and compact and they must bunch together perfectly when wet.
- The brush must yield easily and respond smoothly to the pressure normally exerted by the artist's hand.
- It must recover its normal shape immediately. The bristles must straighten out automatically when, after being wetted, pressure is no longer exerted as shown below.

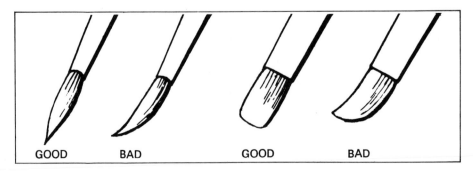

GOOD BAD GOOD BAD

Brushes have three parts, the *bristles*, the *handle* and the *ferrule*, the metal part that holds them together. Brushes for watercolor painting have shorter handles than those designed for oil painting. They are listed according to size which is indicated by numbers stamped on their handles. Smaller brushes have low numbers, such as 2 or 4, and larger brushes have higher numbers, such as 12 or 14.

When painting with watercolors, it is best not to use fine brushes with a very low number because they may create breaks in your washes. It is better to use a thick round brush with a large diameter which will hold a large load of water or watercolor. This also permits rapid and spontaneous work without having to constantly refill your brush. If the brush is good quality, it will have a perfect and compact point, even when thick and wet.

There is little advantage in having a wide range of brushes. In watercolor painting, the brush has to be washed continually in water to lighten or soak up colors, and for merging and shading. Your selection should include two round brushes, a No. 8 and No. 10 or a No. 10 and No. 12, and one flat square-ended No. 12 or 14 brush.

A fine brush such as No. 2 or 4 is useful for poster or commercial work such as painting a label.

CARING FOR YOUR BRUSHES

Good brushes are expensive, so it is essential to take good care of them. Watercolor brushes should only be used for watercolor. Do not leave them in your water jar. Aside from affecting the firmness

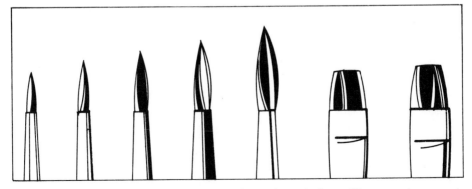

Brushes for watercolor come in several numbered sizes. They can be round and pointed or flat and square-ended.

and flexibility of the bristles, you may damage the glue which holds the bristles in the ferrule. In extreme cases, the wooden handle may warp.

It is best to wash your brushes thoroughly when the work is finished or when they are left overnight. The dry residue of color is particularly damaging to the compact bunching of the bristles. After being washed in clean water, the brushes should be stored with their points upward.

WATERCOLOR PAINTS

Watercolor is a fluid and fast drying medium that depends on its paper for its light. Transparency is one of the special qualities of watercolors. The brush makes a fluid line that is difficult to imitate in oil or any other medium.

The colors are made of vegetable, animal or mineral pigments. Basically these are the same pigments used for making oil paints, but they are bound together with water and gum arabic instead of oil. Sometimes other ingredients, such as glycerine or honey are used to make the gum arabic malleable, which helps prevent separation of pigment after washes are applied. In their final form, watercolors are pastes which are packed in tin tubes or shaped into solid blocks and arranged in small plastic or metal cups.

It is rare today for an artist to prepare his own colors because there are several firms which produce and sell excellent watercolors. Foreign brands such as Rembrandt, Talens, Pelikan and Winsor Newton all make fine paints. In the United States, there are, among others, Shiva, Grumbacher and Bocour.

Most of these firms produce a range of colors which can include up to fifty or sixty different tones. This astonishing variety is due to the fact that in many cases, professional watercolor artists prefer to choose their own stock. However, these manufacturers generally offer tubes or blocks in sets which contain the range of 6 to 24 colors. When they are used up, individual tubes or blocks can be purchased as replacements.

Besides these colors, some sets contain *white,* usually in a tube. It is included as an auxiliary for other colors. For instance, to obtain a specific shade of gray, you would add black to the white. But because

watercolor paintings are made up of transparent washes, adding white to a color tends to make it opaque, so white is seldom used as a mix. But you can use white for very thin white lines. Examples include lines which represent a ship's rigging painted on a blue sky or thin branches on a dark background.

PALETTES

Boxes of watercolors are used both to hold the colors and as a palette in which the colors are made up or mixed. The cover usually has a number of hollows which can be used as cups. They can be filled with small amounts of water for preparing watercolors or preparing mixtures of thicker colors, and for testing the intensity and tonality of a color. Some boxes not only include these hollows in the cover but also in the box itself. Pelikan, shown below, sells its colors in a box

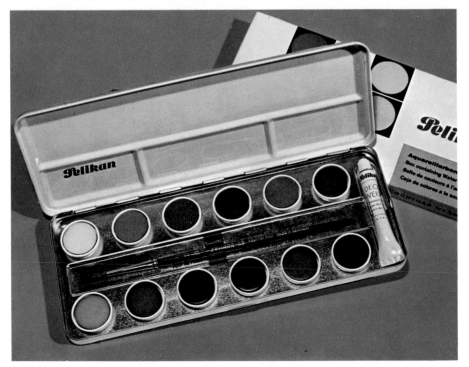

with a double bottom. The colors are packed in a metal container which, when taken out of the box, becomes a large palette with hollows in the cover and bottom.

Palettes specially designed for watercolor are available. Most of them are metal and somewhat larger than the traditional oval or rectangular type used for oils. There is also a special palette box designed for painting with watercolors in tubes that is very popular with professional watercolor painters. It consists of two or three separate units in the form of a folding case. One unit has a series of small square compartments into which color is squeezed from the tube. The rest of the case is divided into smooth hollows similar to those found in ordinary boxes. The box can be closed so leftover paint can be kept in the compartments for use at later sessions.

ORDER OF COLORS ON THE PALETTE
From right to left:

White	Vermilion
Lemon yellow	Alizarin crimson
or medium cadmium	Viridian
Golden yellow	Cobalt blue
or orange-yellow	Ultramarine blue
Yellow ochre	Black
Burnt sienna	

Notice how the colors are arranged from light to dark. White is separated from black by the shades between them, yellow and ochre, vermilion and alizarin crimson, and so on.

An artist may use an ordinary china plate as a palette in the studio, placing the colors from tubes around its edge and mixing them in the center. A white enamel butcher's tray or individual cups made of china or plastic can also be used. No matter what type of palette you use, always be sure that it is white so that you mix your colors on the same color as your paper. This will help ensure you get the proper color mixture.

The colors should be arranged and kept in one order. They should always be placed and mixed in the same area. This makes the work easier and produces purer mixtures of colors.

TESTING COLORS

When working on small paintings in their studio, many professional artists use an ordinary piece of paper to mix and test colors. Brushes are also rubbed on the paper to form a point or unload water.

RAGS, SPONGES AND BLOTTERS

When you are busy painting, all you need for drying and soaking up surplus water from your brush is a clean rag.

Some artists also use a small sponge attached to a brush handle for washing the paper with clean water before painting, for soaking up water and color from a moist area or for putting in special textural effects and finishing touches. Some artists prefer to do all these jobs with a flat brush.

You can also use white blotting-paper to obtain textural effects, soak up water and color or for making breaks. You should experiment on your own.

WATER JARS

Fresh water used for watercolors is placed in two jars, one for washing your brushes and the other for holding clean water for mixing your color pigments. You can buy special jars which have two small notches in the upper edge of their mouth for holding your brush, as shown below. But a glass jam or baby food jar is perfectly suitable.

These jars are only used for studio work. When painting outdoors there are other types which we shall discuss later.

This is a special water jar with notches on the lip for holding your brush.

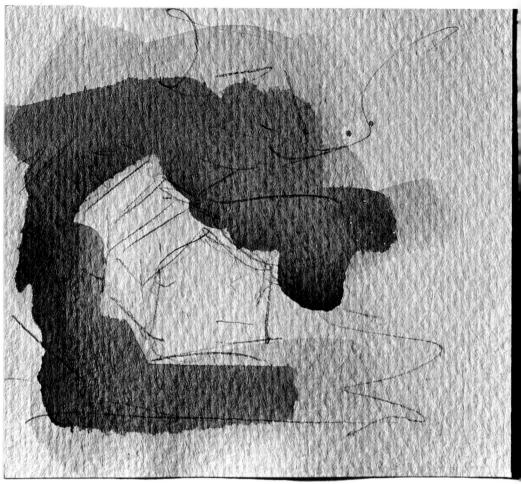

A sample of paper used for watercolor painting.

PAPER FOR WATERCOLOR

Watercolors must be painted on white paper. The type and quality of the paper are extremely important.

You can buy paper either in tablets, called *watercolor blocks*, or one sheet at a time. Handmade sheets vary widely in size, but manufactured sheets are usually fairly standard. Each size has a specific name as shown in the chart on page 39. *Imperial*, which is 22 by 30 inches, is the size used most often.

Paper is also ordered by the coarseness of its surface, called *tooth*, and by weight, which tells you how thick a sheet is. There are basically three paper surfaces for watercolor. *Rough* has a very heavy grain and will absorb dark colors. It is excellent for impressionistic works where

the brush is used like a swab. *Cold pressed* paper has a medium grain and can be used for most styles of watercolor. *Hot pressed* paper has a smooth, open grain that takes washes well. It is probably the best choice for beginners. Fine grained drawing paper is unsuitable for watercolors.

The side of the paper you paint on is called the *right side* and is the side on which the watermark reads correctly.

Watercolor paper is sold by weight which is given in pounds. This is based on the weight of a ream (500 sheets) and ranges from 72 lbs. to 300 lbs. A 72 lb. sheet is quite thin. A 90 lb. sheet is a good intermediate weight. A 140 lb. sheet is fairly heavy. Sheets listed as 250 lbs. or above are more like boards and do not require stretching.

Heavier papers tend to have a warm tone. Lighter papers are whiter.

You can buy several brands of good paper which have the characteristics described here. Brands available in the U.S. include Canson, an English make, D'Arches, a French make, and Fabriano, an Italian brand. Three American brands that can be easily found are Strathmore, Bienfang and Grumbacher.

Watercolor paper mounted on cardboard is also used. Besides overcoming the problem of wrinkling, it also provides a drawing board or support.

As I said in the section on monochrome, it is sensible to try various qualities and types of paper until you find one that is suitable for your skill or speciality.

SIZES OF WATERCOLOR PAPER	
Trade Name	Dimensions In Inches
Royal	19x24
Super Royal	19-1/4x27
Imperial	22x30
Elephant	23x28
Double Elephant	26-1/2x40
Antiquarian	31x53

SUPPORTS

When working in his studio, Guillermo Fresquet generally uses a wooden board to support his paper. He fastens the paper with pins or tacks and he rests one end of the board on the drawing table and the other end on his lap. Then he can tilt the support according to the job he is doing and the effects he is trying to obtain with varying amounts of water and color.

SPECIAL EQUIPMENT FOR PAINTING OUTDOORS

It is possible to paint outdoors with the equipment described here without having to obtain special items. But, it takes more to be really successful. Briefly, this is what you need:

A BOX FOR YOUR COLORS

Solid blocks of paint, also called *pastilles*, are sold in metal or plastic boxes that have lids divided into compartments for mixing and diluting the colors. While this is convenient, the quality and economy of tubes of paint are much more efficient for your use. Tube paints are moist and ready to use. Pastilles dry faster than tubes because they contain less glycerine. Pastilles are also very hard on brushes and are much slower to work with.

If you paint with tubes, you will need a small wooden box or case. You can buy one specially designed to hold the colors, palette, brushes and rags, and a container for water, or you can use a fishing tackle box which will work well and is less expensive.

PALETTE

When painting from tubes it is essential to have a palette. This may be the traditional type similar to those used for oils, or the special type designed for watercolors described previously, or you can use an old white china plate.

BRUSH CONTAINER

Special leather or plastic pouches are available for brushes. They help keep the points and bristles in good condition. Or you can use cardboard boxes and a couple of rubber bands for holding your brushes.

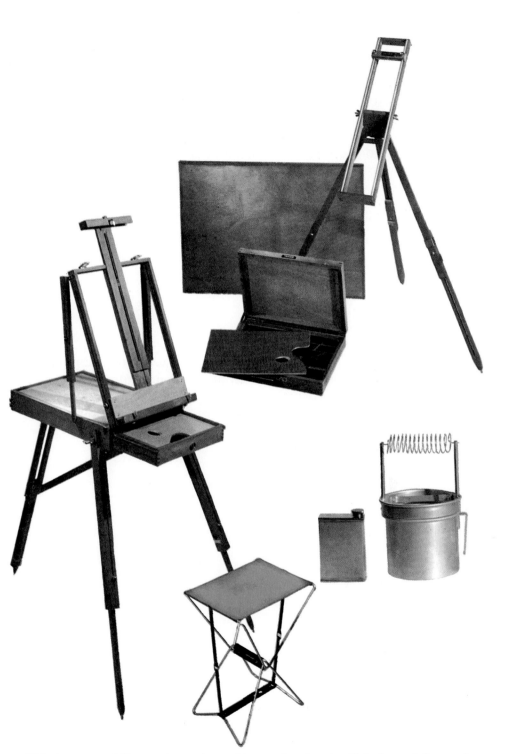

This is some of the equipment used by professional artists for painting out-doors, including an easel, a stool or seat, and a metal water container.

WATER CONTAINERS

Art supply stores offer various kinds of metal containers with screwtops which will hold a sufficient amount of water for outdoor painting. You will also need two smaller plastic or aluminium jars. One jar is needed for clean water for mixing and the second to rinse your paint-filled brushes. Glass jars should not be used because they can break.

PORTFOLIO

Even if you use an easel, you'll need a portfolio for carrying and holding watercolor paper and completed watercolors. In fact, some types of portfolios may save you the expense of buying an easel for outdoor work.

OUTDOOR EASEL

Folding easels specially designed for watercolor painting are available. Some of them have a box attached for holding your supplies. However, it is common practice to use an outdoor easel designed for oil painting with watercolors. In most cases, adapting it consists simply of attaching your support and watercolor paper instead of a canvas for oil painting.

STOOL

Finally, to complete the list, we must remember to bring along a folding stool so that we can sit wherever we want. These have a canvas seat and wooden legs or metal throughout. There are models to suit all tastes and weights.

THEORY AND TECHNIQUE 3

Basic Rules
Colors
Wet-on-Wet
White Areas

When comparing an oil painting with a watercolor, you will immediately see that oil paints are thick, while the washes of watercolor are thin and transparent, and do no more than darken the paper. This transparency is one of the main features of watercolor. It is produced because the colors are weakened or lightened with water instead of white paint.

For instance, to paint a rose tone in oil, you would mix red and white paint to obtain a thick rose with which you can use to paint or even cover a darker color. With watercolor this rose has to be produced by mixing red color with water. You would weaken the red and lighten it with water while allowing for the fact that the white paper will show through the thin red wash. With watercolor *the white of the paper regulates the tone and intensity of the color.* It plays the same part as white paint in oils. A small amount of red watercolor mixed with a large amount of water will allow a considerable amount of white to show and will produce a pale rose. If the amount of red is increased, there will be less transparency and the white of the paper will be less evident, producing a bright rose color. Finally, when the red is mixed with very little water, the wash of paint will cover the white of the paper and produce a strong red, even if the wash is only a very thin film.

If the main feature of watercolor is its transparency, what does this mean in practice?

WITH WATERCOLORS IT IS IMPOSSIBLE
TO SUPERIMPOSE LIGHT COLOR ON DARK COLOR

Imagine that you are painting a purple with oils. Could you paint a light yellow over it? Of course you could. You may have to wait until the purple coat is dry, but you would certainly have no difficulty

in painting a light yellow over it. To obtain a light yellow with water-color, you have to dilute a small amount of yellow with water. This will produce a wash whose color is incapable of overcoming and covering the intensity of the first purple wash.

YOU MUST WORK UP AND OUT
FROM THE CENTER OF THE PAPER

If it is impossible to paint light colors over dark, there is, of course, no way except to paint up and out, to gradually intensify the tone and color. We can always darken a light blue by adding another wash of blue, but we cannot lighten a color by adding paint, which brings us to the third factor.

WHITE AND LIGHT COLORED AREAS
MUST BE MARKED OUT IN ADVANCE

Assume for a moment that you are painting a landscape with a white cottage surrounded by trees and thickets. First you must paint

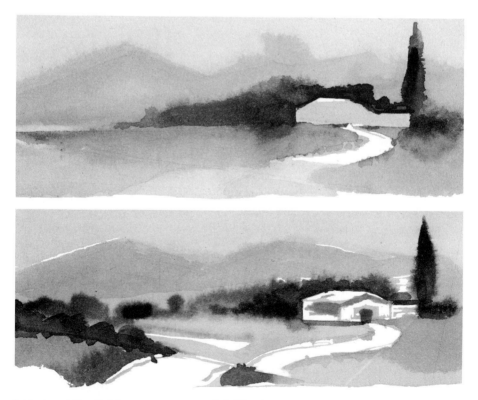

Leave out the light areas as you paint. The house and road will be lighter than the surrounding trees and fields.

the green of the bushes and trees, leaving out the white area of the house as shown on the facing page. If a light earth-colored lane runs beside the house, the light sienna of this area will have to either be painted first or you must mark out the shape of the lane and not paint on it if you choose to do it later. Then you have to superimpose the dark sienna bordering it, working up and out. You can emphasize the border with another wash, intensifying the color of the lane and its edges.

CREATING COLORS

Being able to intensify tones by adding washes of color means that you can sometimes change or blend colors on your painting. Imagine, for instance, that you have painted a green field. After you put on the first wash you find that the green is too yellow. All you need do is to apply a wash of bluish green or sky blue, which will turn the previous green bluish, covering its yellow tint. This field may also contain a tree or some darker green bushes with a reddish tinge. All you need is to paint a reddish green or even a dark rose over the pure green and, with the color of the first wash coming through and combining with the transparency of the second, you can obtain the shade you want.

This is how watercolors are produced by painting up and out, with dark colors on light colors. And it leads us to creating new colors by superimposing or mixing. Let me stress that with just the three primary colors, blue, red and yellow, it is possible to obtain all the colors of nature, including black.

PRIMARIES + PRIMARIES = SECONDARIES

Red + yellow = orange
Yellow + blue = green
Blue + red = violet

PRIMARIES + SECONDARIES = INTERMEDIATES

Yellow + green = yellow-green
Green + blue = blue-green
Violet + blue = blue-violet
Violet + red = red-violet
Red + orange = red-orange
Orange + yellow = yellow-orange

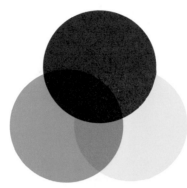

Mixing Colors
From the three primaries, red, yellow and blue, you can create all the colors.

As you probably already know, if two of the three primary colors are mixed together, they produce a secondary color. Mixing these with primaries provides us with six intermediate colors as shown on the facing page. If we then mix the primaries and secondaries with the intermediates, we obtain an infinite range of colors.

WORKING RAPIDLY

Watercolor has been called the painted expression of a momentary impression, a work which tries to capture a landscape in a particular instant, just as long as it takes to paint that sunlight, those colors, and those effects of light and shade. Under these circumstances, the artist's attitude resembles a kind of fever which affects all his faculties. He is completely involved. His sense of proportions and dimensions, his memory of forms, his perception of color, his ability to see, draw and paint are all involved in this one painting. That is why no more than two hours should be needed to paint a landscape in watercolor.

This rapid conception and execution is one reason the *wet-on-wet technique* is greatly valued and practiced by many modern artists.

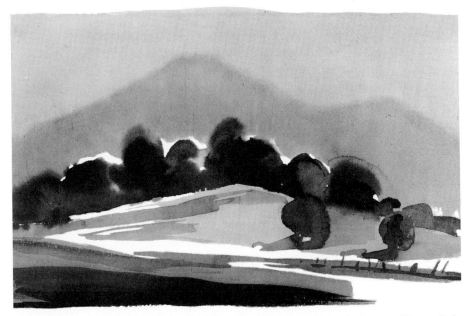

Wet-on-wet technique produces masses of color without firm outlines. It is often used for landscapes, seascapes or for backgrounds for dry-brush technique.

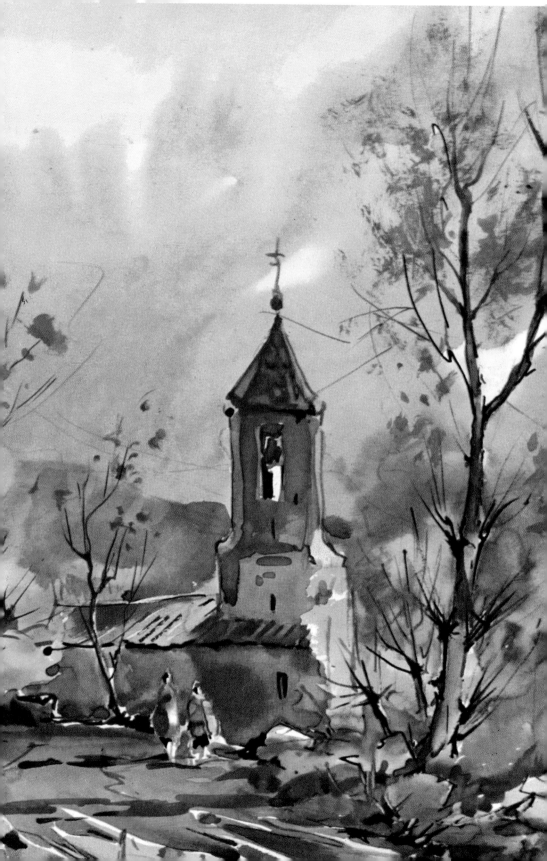

WET-ON-WET TECHNIQUE

This technique is very simple. First you moisten the paper with clean water and, without waiting for it to dry, paint a green field in the foreground. Again, without waiting for it to dry, put in a range of mountains in the background. Using the moisture on the paper, add a darker green over the first green to make a strip of trees and blades of grass. Continue this way, soaking up water to delineate shapes, make contrasts or add color. This is wet-on-wet technique, a special style where the shapes have no firm outlines, particularly the distant objects and masses as shown on the facing page and on page 47.

The effects produced with this technique are particularly useful for subjects with little contrast such as gray landscapes without sun, foggy seascapes or rainy scenes. It is also usually suitable for backgrounds, for example, clouds in a sunny landscape.

PAINTING LIGHT COLORS ON DARK

We now turn to the special techniques which can produce exceptions to the theoretical rules. Using the wet-on-wet method, it is sometimes possible to paint light colors over dark.

The method is simple if you remember the technique for producing white areas explained on page 44 and in the section on monochromes on page 21. In fact it is easier in this case because the dampness of the paper and the color is nearly constant. You soak up the original dark color and lighten the area. As before, you need only clean your brush, wipe it and soak up the wash and color on the area you want to lighten.

This method is only valid for obtaining *atmospheric whites*, which are dirty white areas that retain the hue of the previous color. But this is all right because pure white does not exist in most scenes.

This method is also useful for changing a color. All you do is paint over the lightened area, but you must allow for the fact that the second color is bound to be influenced by the first, however much you may try to hide it. So, remember the rules of color harmonization. A picture should consist of a specific range of color, a dominant tone. When the tones harmonize, this technique will work well.

In this superb sketch by Guillermo Fresquet is an example of the potential of *wet-on-wet technique,* a method based on applying color on wet paper or wet washes of paint.

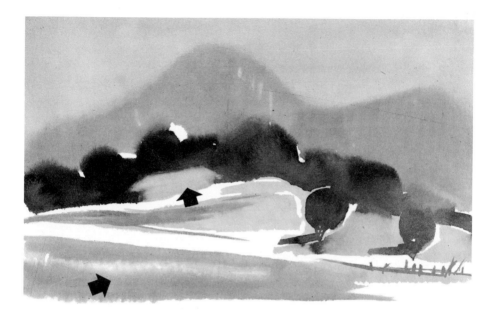

You can lighten some dark areas by soaking up color as we did in the section on monochromes. Remember, you can never get a pure white.

MARKING WHITE AREAS WITH WAX

If you mark a piece of white paper with a strip of pure wax, and paint over it with diluted watercolor, the color will not take on the waxed area. The waxed area remains white while the surrounding areas become colored. For example, to mark out the mast of a boat and the reflection of its mast in the still water of a harbor, you need only sketch the mast and the highlights in the water with a lead pencil, and paint them with wax. Then you can paint over them with a brush soaked in color. The waxed areas will remain a clear, pure white.

This method is sometimes used to obtain special textures. Waxing large patches with different size strokes of wax will produce stippled colored planes or irregular speckled areas.

RECOVERING WHITE AREAS

Theory and, in this case, practice say that in watercolors the white areas must be marked out in advance and produced by the white paper. But theory makes the rules and skill breaks them. Sometimes you need an area of white in your composition but you've already covered it with color. Don't worry, there are ways.

MAKING SMALL WHITE STROKES

A landscape, seascape or still life frequently contains small highlights or light areas in the shape of heavy regular or irregular strokes. Examples are the highlight on a branch or the shape of a thin tree trunk. It would require considerable effort to mark out such a form in advance to allow the white paper to show through.

Instead, the common method is to reveal or *open up* the white area with the tip of your brush handle. The tip must be cut in the shape of a wedge and the area to be opened up must be wet. But be careful. The wedge-shaped tip must be smooth, worn and rounded so that it produces a broad stroke in one movement without scratching or damaging the surface of the paper. The area must be only slightly wet and the color only just applied. If proper conditions exist, rubbing the area with the wedge of the brush will remove the color and reveal the white of the paper as shown at the left below.

Fresquet makes lines by "drawing" with the tip of a fingernail in one quick stroke from right to left, removing the color as shown in the figure on the right below.

PAINTING WITH WHITE WATERCOLORS

As I mentioned before, you can obtain small white areas, such as dots or very thin lines, by applying white watercolor rather thickly to cover the underlying color. This will only work on small areas.

Now you know these tricks but please don't misapply them.

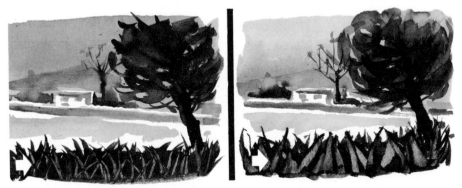

Small white areas can be revealed by scraping the painting with a flattened brush handle, as shown on the left, or by marking with your fingernail, as on the right.

4 PRACTICE WITH WATERCOLORS

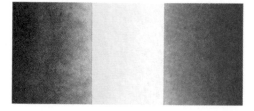

Three Colors and Black
Mixing Colors
Painting an Apple
Painting a Still Life

Because you have already practiced with monochromes, I won't repeat my explanation of how to paint an even, flat surface or how to remove color from an area just painted. Everything you learned there can be applied to watercolors. In the following projects I assume you have completed those exercises. As we paint I will point out special techniques. We will begin with three colors and black.

WITH THREE COLORS AND BLACK

The object of this exercise is to show you that every color in nature contains a certain amount of each primary: blue, red and yellow. For example, ochre is produced by mixing a large amount of yellow, a smaller amount of red and an even smaller amount of blue. Olive green is composed of yellow and a small amount of blue together with a very tiny amount of red. Black or very dark gray is obtained by mixing more or less equal amounts of all three colors.

Once you know the potential of these three, the problem of mixing colors will be solved. When you try these first exercises, I suggest that you remove all but the three primaries and black from your box to prevent any confusion.

On pages 54 through 60 you can see the colors you will match in this exercise. These 36 colors are all obtained from the three primary colors and black. Before you begin to paint a proper subject, you need to know what colors to mix to obtain any specific tone or color.

Start with a sheet of watercolor paper and a soft pencil. Very faintly draw four large squares along the left hand edge for the primaries and black. Then draw 36 1-inch squares which you will use for composing the colors you will mix.

Remember that paper wrinkles easily when it is moistened which will make your work more difficult. To prevent this you should use the method for mounting and stretching the paper as explained on pages 13 and 14, or follow these simple steps.

● Moisten the whole surface of the paper with clean water, using a wide brush, small sponge or clean rag. If you use a rag, rub very gently to avoid damaging the surface of the paper.

● Place the paper on your drawing board and leave it there for a short while to allow the surface to expand. This allows the fiber to stretch as it absorbs the moisture.

● Then, before the paper can dry, fix it to the board with eight or more tacks or pins. This will keep it stretched as it dries.

If you take these precautions, there will be very few wrinkles when you paint.

MATERIALS

Lemon yellow or Medium cadmium yellow	Paper
	Water
Alizarin crimson	No. 10 brush
Ultramarine blue or Prussian blue	Rag for drying your brush
Black	Scrap of paper for testing colors
Drawing board	

THE EXERCISE

Hold the scrap of paper for testing colors in one hand and the No. 10 brush in the other.

Begin by painting simple shaded areas as you did when painting your monochrome. Paint separate areas of yellow, red, blue and black without mixing them. These are shown on page 54.

Now paint the specimen colors, working from left to right. To obtain the right color you must read the description of each color and mix that color on your palette. Test the shade on your scrap paper and adjust it if you need to. Then paint the final color.

Obviously it would be best if you obtained the right color on your first try without having to darken or lighten it. However, you will usually have to change some colors on the paper. When you do,

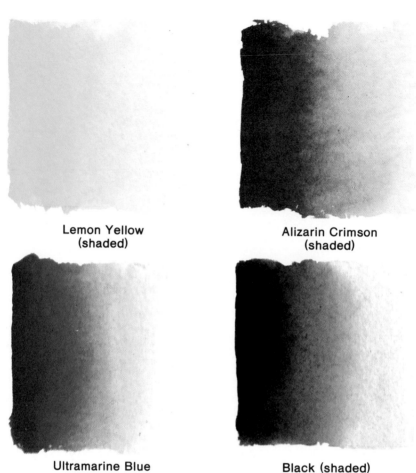

Lemon Yellow (shaded)

Alizarin Crimson (shaded)

Ultramarine Blue (shaded)

Black (shaded)

remember these rules. If you make a mistake, it is always better to strengthen or change color by adding another wash. In principle, it is best to change the color by working on a wet area. However, a final wash may be needed and this must be put on after the previous wash is dry.

These are the colors. Please paint them in the order they are listed.

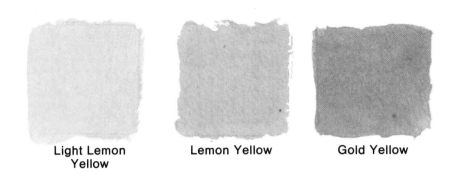

Light Lemon Lemon Yellow Gold Yellow
Yellow

Light Lemon Yellow—Simply mix lemon yellow and water.

Lemon Yellow—Mix yellow with less water to make it stronger.

Gold Yellow—First paint a strong yellow as before. Then, while the yellow is drying, add a very light wash of alizarin crimson. Be careful, alizarin crimson is very strong. A mere touch of it is enough to produce the slight red tone required here.

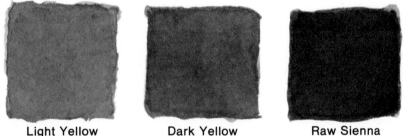

Light Yellow Dark Yellow Raw Sienna
Ochre Ochre

Light Yellow Ochre—First make the gold yellow above. Add a small amount of blue and black while the first wash is still wet. Be careful with the blue and black. They are strong.

Dark Yellow Ochre—As above, adding a very small amount of alizarin crimson, blue and black.

Raw Sienna—Begin by mixing gold yellow. Leave it for a few moments to acquire body and deeply tint the paper. Before it is completely dry, add red-violet which is made from alizarin crimson and a little blue with just a touch of water. It is important that this violet wash have a slight touch of alizarin crimson.

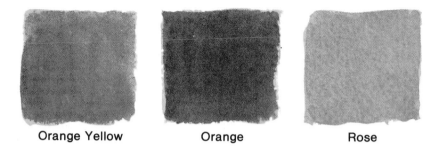

| Orange Yellow | Orange | Rose |

Orange-Yellow—This is a very thick paste-like yellow with alizarin crimson added while it is still wet. Gradually increase the amount of alizarin crimson until you obtain the color in the model.

Orange—Mix as above, but with more alizarin crimson.

Rose—Dilute alizarin crimson with water and add a touch of yellow.

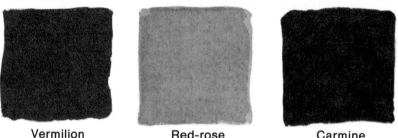

| Vermilion | Red-rose | Carmine |

Vermilion—Use a lot of yellow, thick and paste-like. Then add alizarin crimson which must not be so strong that the yellow does not show through.

Red-Rose—Dilute alizarin crimson with a large amount of water and add a touch of blue.

Carmine—First paint a wash of blue on the paper. Then, while the blue wash is still slightly wet, add strong alizarin crimson.

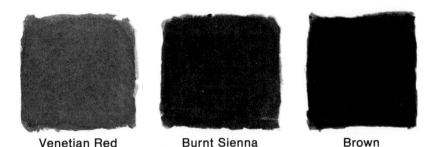

| Venetian Red | Burnt Sienna | Brown |

Venetian Red—First mix a rather bright orange and then, while it is wet, add a little blue to make it grayer. This should produce a sienna with alizarin crimson as the dominant tone.

Burnt Sienna—Mix a strong, paste-like yellow and alizarin crimson to produce a bright orange. While it is wet, add some blue. It may be necessary to add more alizarin crimson to obtain this dark reddish color.

Brown—Add more blue to your burnt sienna.

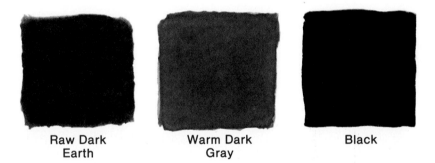

| Raw Dark Earth | Warm Dark Gray | Black |

Raw Dark Earth—We are now dealing with dark colors which can cover lighter ones. With these you must work with more paint and less water. To obtain this color first produce a dark ochre by mixing a lot of yellow, a little alizarin crimson and a little blue. Then mix in a raw sienna, still using only a little water and painting while wet, mixing on the paper. Finally, strengthen the color with the three primaries, darkening the sienna and adding black if necessary. This should produce a dark earth color with a cold, bluish tone.

Warm Dark Gray—The warmth is produced by a dark yellow ochre in the dominant gray. There are two ways to make this color. You can

mix the three primaries in more or less equal amounts and paint them on a dry wash of dark yellow ochre. Or you can apply a light wash of gray to the paper first. When it is dry, apply a thin wash of ochre made from gold yellow with a little blue and black. Either way, it is not a difficult color to obtain.

Black—Use the black paint from the tube. Keep it slightly thick so that it covers.

| Light Green | Bright Green | Dark Green |

Light Green—Mix a rather bright yellow with a little blue.

Bright Green—Again, mix bright yellow, but add more blue.

Dark Green—Mix as above, with more blue and a little black.

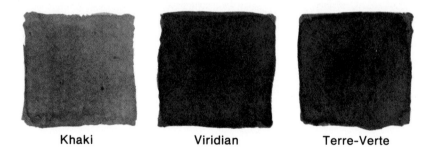

| Khaki | Viridian | Terre-Verte |

Khaki—Begin by mixing a light green which is applied in a wash to your paper. Without waiting for the paint to dry, apply a mixture of a little alizarin crimson and yellow. It may be necessary to add more blue and yellow and possibly a touch of black.

Viridian—Viridian green is a strong bluish-green. Mix it from yellow and a lot of blue; nothing else.

Terre-Verte—Mix a strong paste-like yellow and a very small amount of blue to produce a dirty olive green. While wet, quickly add a little blue.

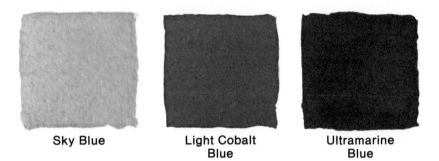

| Sky Blue | Light Cobalt Blue | Ultramarine Blue |

Sky Blue—Dilute some ultramarine blue and apply it to your paper. While it is still wet, add a touch of yellow to offset the purple tinge. Use a very small amount of yellow so that it does not change the bluish shade.

Cobalt Blue—This is a strong blue but not paste-like. It is slightly stronger than medium blue. Add a little yellow as before to offset the purple tinge.

Ultramarine Blue—Use blue directly from the tube. It should be thick but not paste-like.

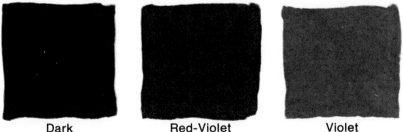

| Dark Ultramarine Blue | Red-Violet | Violet |

Dark Ultramarine Blue—Mix a thick, paste-like blue with a touch of alizarin crimson and black. Use very little of these two.

Red-Violet—Mix blue with alizarin crimson. Dilute it with enough water to let the white of the paper show through.

Violet—This is a wash of blue and alizarin crimson, more transparent than the one above because it is made with more water.

Medium	Dark	Warm
Neutral Gray	Neutral Gray	Medium Gray

Medium Neutral Gray—Dilute black enough to be transparent, allowing the white paper to show through.

Dark Neutral Gray—As above with more black.

Warm Medium Gray—Dilute black to produce a medium gray. Add a little yellow and alizarin crimson to give it a warm tone.

Cold	Cold	Black
Medium Gray	Dark Gray	

Cold Medium Gray—Mix a neutral gray as before, then add a little blue while still wet.

Cold Dark Gray—As before, but add more black and blue.

Black—The black paint from your tube, thick enough to cover.

PAINTING AN APPLE

MATERIALS	
Lemon yellow or Medium cadmium yellow	Water
	No. 10 brush
Alizarin crimson	No. 6 brush
Ultramarine blue or Prussian blue	No. 2 brush
Black	Rag for drying your brush
Drawing board	Scrap of paper for testing colors
Paper	No. 2 pencil

Begin by quickly sketching the apple with a No. 2 pencil, producing a two-dimensional, unshaded drawing shown below. Then, using a thick brush, moisten the surface of the drawing with clean water. Use only a little water. The aim of this first wash is to remove any grease or dust left on the paper so that the washes will be more fluid. Wait until the surface is dry. Then you can begin painting.

FIRST STAGE

Paint the entire apple, except the white area of the highlight, with a coat of diluted lemon yellow retaining enough color to cover. Paint quickly without being too fussy. Keep within the outline of the subject, but remember the drawing is not firm and absolute.

While the yellow is still fresh and completely wet, add a few strokes of alizarin crimson weakened with water. Paint the patches which will be in the dark sections of the apple. The wetness of the

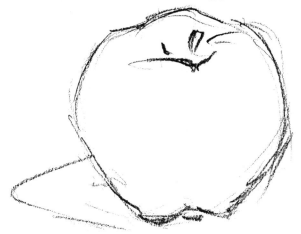

Do not make a careful drawing of the subject to be painted. Only make a few strokes to outline the apple.

yellow and alizarin crimson will cause the alizarin crimson to spread and blend so that the patches automatically disappear and the two colors combine to produce orange.

SECOND STAGE

Still painting while the surface is wet, add more yellow, then clean your brush and add alizarin crimson as before in irregular patches. These patches will mix and blend with the yellow because of the moisture.

Now mix yellow, alizarin crimson and a little blue to produce an earth color with an alizarin crimson tinge. Test these colors on your scrap of paper. Apply it strongly in the shadowed areas. Dry your brush on a rag and gently stroke those shadowed areas, blending the shading of this darker color with the previous orange shade.

Make the color of the shadow cast by the apple by mixing a touch of yellow, a touch of alizarin crimson, blue and a bit of black. Test it on the scrap of paper and correct it. Then paint the shadow in one stroke from left to right. The orange tint should mingle with the gray in the shadow.

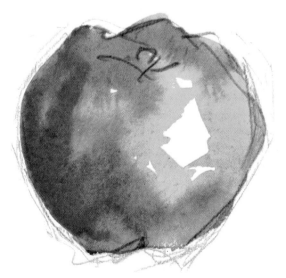

Notice the effect obtained by superimposing alizarin crimson on the wet yellow. Then apply a few random patches of alizarin crimson which blend because of the moisture.

THIRD STAGE

As the work advances upward and outward, the colors become less diluted and thicker. So, of course, the moisture is reduced, producing firmer brushstrokes.

While the painting is still wet, outline the fruit with touches of alizarin crimson and blue mixed with a little yellow to produce an alizarin crimson-tinted sienna. Emphasize the more deeply shaded areas, adding a little black to the other three colors.

Now add paint and soak up color to get the right colors. From time to time apply a clean, wiped brush to remove color and reveal lighter areas.

Stop painting. So far we have been working feverishly. We have reached this stage in less than fifteen minutes.

Carefully study the model and your painting. Emphasize the color of the shadow by painting with blue and alizarin crimson. Look for a dirty gray color on your palette, and add a touch of this dirty gray to the shadow while it is wet. Stop again and study your work.

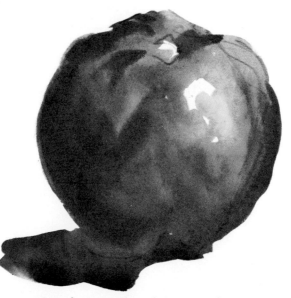

Still working on a wet surface, apply paint on previous wet washes to blend colors and obtain smooth, spontaneous shading. You should be especially concerned with producing the *form* and *volume* of the fruit.

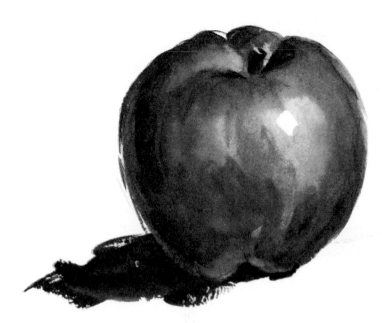

Above is an advanced stage of this exercise. The apple has its full form. Only the coloring and final details are missing. Below, the finished work after soaking up water and color, using the brush as a sponge to change and adjust colors.

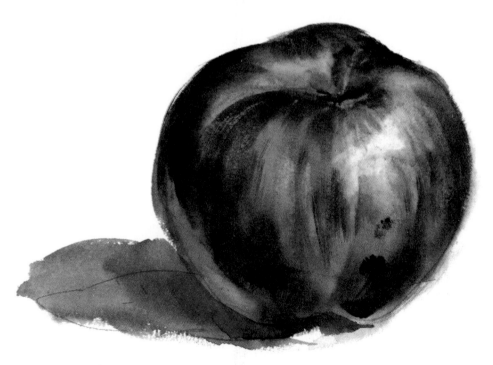

FOURTH STAGE

With a clean brush and clean water, wet the left side of the apple and the shadow. Soak up all the color, leaving a light, dirty gray with a dominant cream color. Tint this area with a brighter gray containing a blue tinge. Emphasize the light reflected from the apple, the bluish-green strip on the right with a little yellow, allowing the moisture to spread it.

Wash and soak up water and color in the center and front of the fruit, working quickly, painting on the wet surface. Now work on the shading, rapidly soaking up water and color, emphasizing, reducing, giving form and color to the subject until you obtain the final result shown in the lower figure on the facing page. But stop before you overdo it. Don't overwork your painting. Now, let it dry.

FINAL TOUCHES

Add some yellow and a little blue.

Draw and paint that sort of border which outlines the apple using the dirty alizarin crimson left in the hollows in your box.

Add light green near the stem and alizarin crimson and black in the more shadowed areas along the left edge. You might add a touch of yellow in the center.

When the watercolor is dry, use an almost dry brush to paint the cross-strokes, red patches and the dark bruise on the lower left side.

At last, you are finished.

PAINTING A STILL LIFE

Still working with only the three primary colors and black, we are ready to paint the still life shown on pages 70 and 71.

I have prepared the subject: an apple, two bananas, a green ceramic vase and a lemon on a table.

MATERIALS

Alizarin crimson	No. 10 brush
Cadmium yellow	No. 6 brush
Ultramarine blue	No. 2 brush
Black	Rag
Drawing board	Scrap paper
Paper	HB or B pencil
Water	

We begin by drawing the subject with rapid strokes using a soft lead pencil. You should create a sketch like the one on the facing page. Don't bother to draw in the details. You will be able to put them in with color.

THE FIRST STAGE

First look at the painting on page 68. Then wet the paper with clean water. Without waiting for it to dry, very rapidly add the basic colors in this order.

Begin with the background, starting on the left. Paint a wash of dirty ochre made by mixing yellow, alizarin crimson and black with a lot of water.

Without washing your brush, take a little blue and black with a little water to weaken it and test it on your scrap of paper. If it's the color you want for the right side of the background, go ahead and paint. Strengthen this color with blue and black and, while it is wet, paint in the shading which outlines the tablecloth.

The vase is next. Mix a light green from yellow and blue, and paint it without the highlights. While it is still wet, add another wash with more color using a darker, thicker green, sketching in and giving the vase volume. Then add a few touches of blue-black around the edges.

The tablecloth is painted blue-black using the previous mixtures and those indefinable colors which always gather in the hollows of the box while you work.

Now for the apple. Without cleaning your brush, take yellow and mix it in the box with the previous gray. Paint with just that, leaving

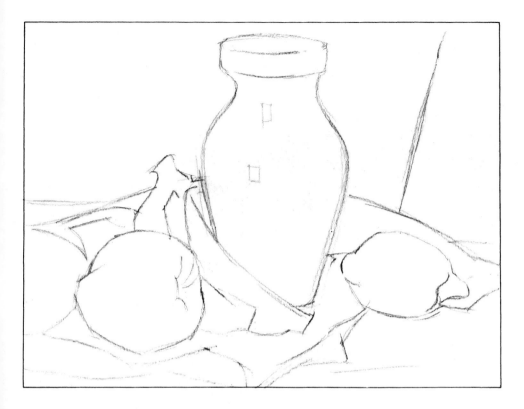

out the highlight. Then take some yellow and dab it on the first wash. The moisture will spread and blend it.

Switch to the lemon, after washing your brush. Take yellow and water and give it the first wash, leaving out the white area.

The bananas are done quickly with the same yellow.

Now return to the apple which is still wet. Use the dirty gray mixtures in your box and add alizarin crimson, a little blue, more alizarin crimson, and water, and paint the darker areas of the apple.

Now move rapidly to the table in the foreground. Mix a greenish gray from the left-over gray mixtures and a little yellow and blue. Paint with plenty of water.

Go over the lemon again with yellow ochre to shape it. Because it is not completely dry, the color will spread and blend but you will have to help in shading the luminous section in the center by wiping the brush on your rag and soaking up the color.

While the bananas are still wet, take the greenish-gray mixed for the table and give the bananas volume with those vague greenish touches. Next use a brushful of orange on one of them.

THE SECOND STAGE

Continue working on the wet surfaces for nearly every wash. The figure itself should be enough to show that you should work with a range of colors similar but stronger than those used in the first stage.

Briefly, begin with the background using a wash of light sienna. Then strengthen it while wet by applying bluish and alizarin crimson shades. Darken the other colors, making their tones more definite by adding further washes. The first washes should be still wet enough to blend the shading automatically, except in areas such as the sections of the tablecloth and bananas where dry, vivid strokes will give a firm outline. Begin to superimpose dark greens on the vase, mixing them from blue, yellow and black. The peculiar alizarin crimson patches of the apple are also added at this time.

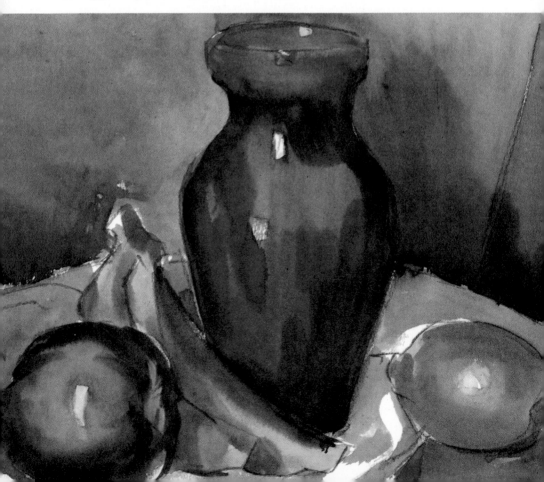

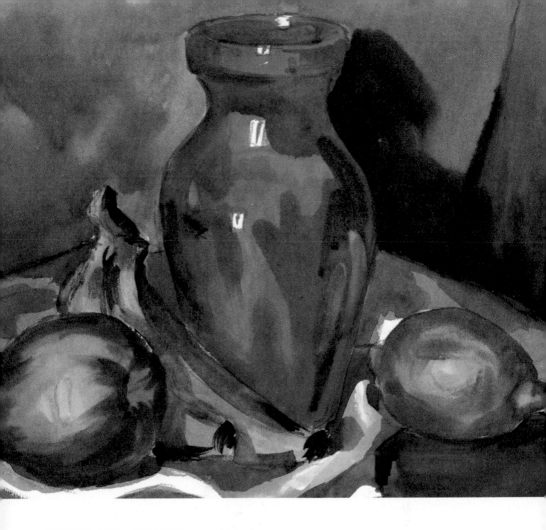

THE LAST STAGE

We can see the finished watercolor painted by Fresquet reproduced on the next two pages.

Fresquet took two hours to produce this work. Study the sections which show that he worked on wet surfaces. Examine carefully the coloring of the green vase which was obtained by superimposed brushstrokes, leaving out the highlights and reflected lights and adjusting the color. Remember that every shadow contains blue and sometimes black. To make a color grayer, blue is always necessary. Any dirty color contains blue.

Also examine those areas that were painted with an almost dry brush, scraping the color. A good example is the upper left edge of the apple.

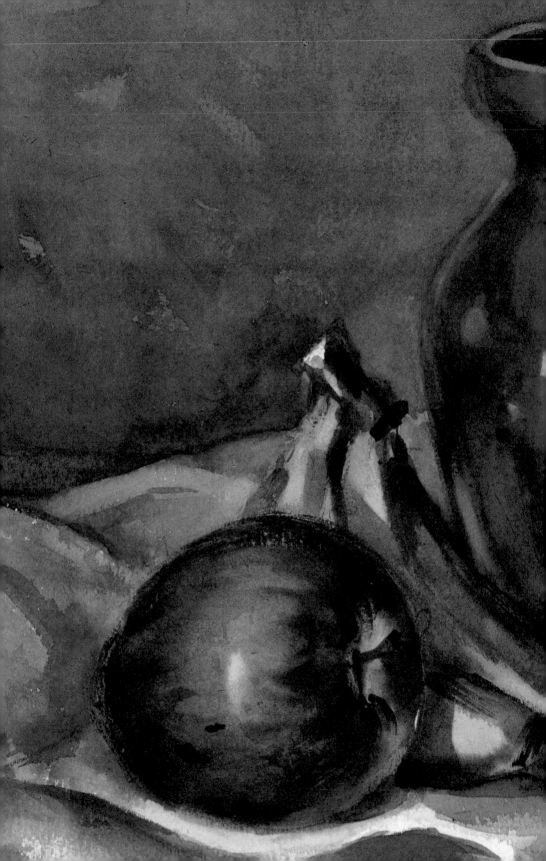

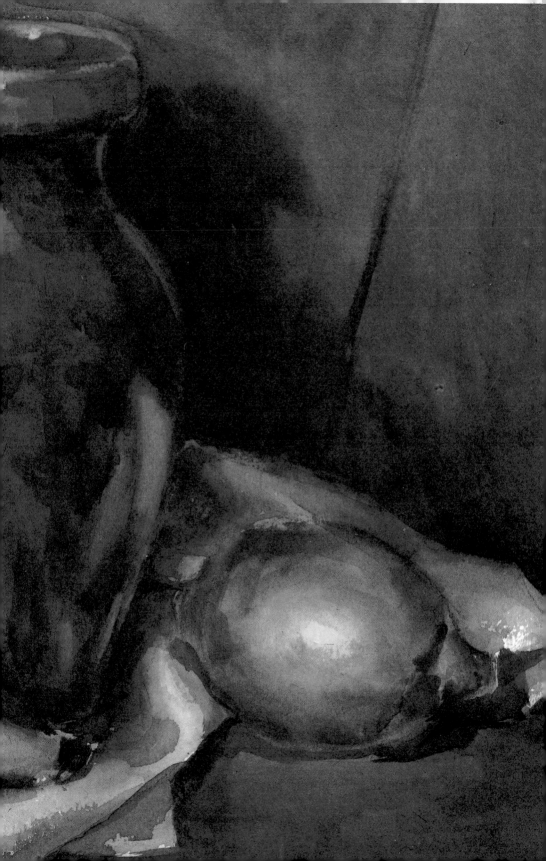

5 PAINTING WITH ALL THE COLORS

Composition
Light
Dry-brush Technique
Painting a Landscape

Just as you cannot multiply without having learned how to add, you cannot begin to paint with every color in your box until you have practiced and obtained every color in nature using only black and the three primaries: blue, red and yellow.

First you painted monochromes in only one color: black. Then we worked with three colors: blue, alizarin crimson and yellow. Now we will use every color.

CHOOSING A SUBJECT

Fresquet says that he does not find a subject by chance. He analyzes and searches for a subject, relying on three factors: his memory and experience of earlier images, his knowledge of locations which are often artistic scenes and his selective ability based on his skill in composition. Here are some suggestions to help you select your own subjects.

GAIN EXPERIENCE BY ANALYZING WORKS BY MASTERS

Visit exhibitions or, if that is impossible, study good reproductions. Cut out and collect pictures from periodicals and journals which contain paintings by recognized artists. Build up a select library of art books. Analyze these reproductions by studying them and even drawing small sketches of them so that you understand what the artist did and why. This will help form your taste and enable you to select subjects for yourself.

VISIT LOCATIONS FREQUENTED BY ARTISTS

That means going to places which have been painted or where artists are known to paint. This is not just theoretical advice. If you

know that some spot is frequented by painters, or that particular district of the city is sometimes visited by professionals with palette in hand, then go there and try to discover what attracts artists. Painting where others paint gradually gives you the ability to discover new places to paint original subjects.

PRACTICE COMPOSITION BY DRAWING SMALL SKETCHES BEFORE PAINTING

When you have selected your subject, it is time to decide on the most suitable frame, viewpoint, light and contrast. It is best to make two or three preliminary sketches. This enables you to study your subject and to help develop the best composition. The basis of all art is good design and quality is the ultimate result. Good design needs a focal point. Design techniques are discussed in more detail in *How to Compose a Picture*, another volume in this series.

COMPOSING A LANDSCAPE

Above all, you must examine the subject from every possible angle. Analyze the location of some shapes in relation to others and try to obtain contrasts in colors and shapes. The direction, intensity and quality of the light are important in this connection. Also try to imagine how you will frame your scene. One way is to make a black cardboard frame enclosing an area of some four to six square inches as shown below.

The traditional composition of a landscape is based on a subject in a prominent foreground backed by two or more planes which

The model cannot move but you can. Study every possible angle. Look at it from above, below and all sides. To help you envision the frame, use a cardboard frame like the one illustrated here.

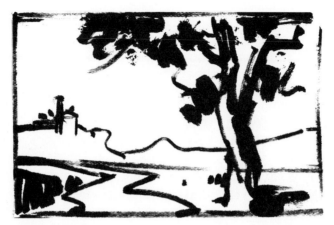

Here is an example of framing an image with a foreground made prominent by shape and tone. This is a safe composition. This foreground also acts as a perspective plane and produces a sense of depth while increasing the unity of composition.

Do not paint at noon when the sun is at its height. Shadows either do not exist or are unpleasantly harsh.

Large skies and low horizons are always an effective subject.

Use perspective as a means of imposing order on a composition, but do not make these effects too obvious. Avoid a well ordered, monotonous arrangement.

increase the sense of depth. This foreground is emphasized and brought out both by shapes and tonal contrasts. This traditional formula can be discarded when you have enough experience and knowledge to choose more original and freer compositions.

The tonal and chromatic mass of the sky can often be a decisive factor when arranging and harmonizing a composition. In watercolors, cloudy skies can produce decorative effects and also be the occasion for great technical brilliance. For the most effective composition, never place the horizon in the center of your picture.

Finally, when composing landscapes, do not overlook the possibility of using perspective to create unity within the framework of variety. To produce this effect you should place yourself where the center of perspective, the meeting point of lines running toward the horizon, is not too obvious, as shown above.

LIGHT

In the beginning you should look for a subject with clearcut highlights and shadows, and well defined volume and contrasts. I advise

you to paint before or after noon to avoid the period when the sunlight is almost vertical and more or less eliminates shadows from objects. Also avoid cloudy days for now. They do not offer enough contrast.

FRESQUET EXAMINES THE COMPOSITION OF A PICTURE

A professional such as Fresquet may realize right away that an object is worth painting. He can quickly determine that the light is at its best for emphasizing the values of the subject, or that the shape, arrangement, color and contrast between the various planes can work together to produce a good painting. But, as Fresquet himself admits, a professional usually wants to confirm this first impression, grasping it and perfecting it with a simple pencil drawing.

You can see on the facing page some of the pencil sketches made by Fresquet to obtain and examine the composition. Notice how these sketches have been made, using patches of pencil rather than lines. The idea is to fix the frame and examine the effects of light and shade in relation to the composition.

Now we have a subject. Imagine that we are with Fresquet beside the road approaching a town. The houses are placed in a line in the middle plane separated from us by the green and earth of some gardens and trees. It is ten-thirty in the morning of a spring day. The sun lights up the scene, producing strong contrasts in the interplay of light and shade. If we squint our eyes, we could say that there are only two colors: a light yellow in the sunlit areas and a bluish sienna in the shadows. The impression of volume is astonishing.

But, before we follow Fresquet through the completion of his painting based on this sketch, we need to discuss the two basic types of watercolor painting.

TWO CLASSIC METHODS OF WATERCOLOR

You already know the theory of wet-on-wet technique. It is characterized by painting on wet paper. This blends the colors and softens the outlines. You know too, that you must paint a succession of washes, working up and out. This is done by applying light colors and tones first and superimposing dark colors and tones later.

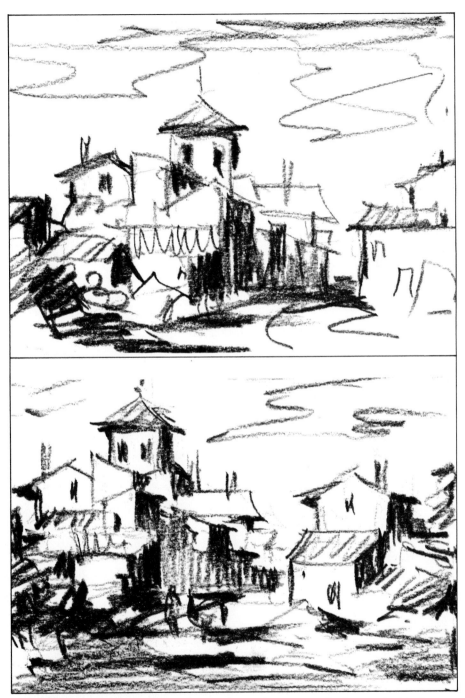

Here are two rough sketches Fresquet made as a preliminary study of composition before painting the watercolor described in the following pages. In the upper sketch, the center of interest, the road entering the town and forming a street between the houses, is too far off-center to be effective.

Dry-brush watercolor is in some ways the exact opposite. The paint is usually applied on dry paper with the brush only slightly moistened by the paint. The darker colors and tones are applied first, allowing each wash to dry before applying the next. The dry-brush technique gives a pattern and definition to your painting.

But you will see what happens in practice when we watch and comment upon Fresquet's work as he paints a dry-brush watercolor.

PAINTING A DRY-BRUSH WATERCOLOR

MATERIALS	
Lemon yellow	Drawing board
Golden yellow	Paper
Yellow ochre	Water
Burnt sienna	No. 10 brush
Vermilion	No. 6 brush
Alizarin crimson	No. 2 brush
Viridian	Rag
Cobalt blue	Scrap paper
Ultramarine blue	HB or B pencil
Black	

Whichever method you use, you must begin by wetting the paper with a thick brush and clean water. This will remove any dirt left on it and keep the color from running or the paper from wrinkling under the effect of wet washes. Wait until the paper is completely dry, then make a quick sketch of the subject with a soft lead pencil. This sketch should be very simple and should contain no shadows or gray or black areas.

While he is sketching in the shapes and profiles, a farmer goes by on the road leading a donkey. Fresquet watches them for a few moments and then draws the man and animal at the bend in the road. Then, as if reminded of something, he draws an indication of another figure farther in the background.

FIGURES AND COLORS

Consider adding a figure to your sketch. One or more human figures provide color and give a feeling of reality to a painting. You might say it brings the picture to life. Notice that Fresquet has painted two figures and, almost instinctively, decided to use red for the first and blue for the more distant one. He will paint the sacks on the donkey with a small but clear touch of yellow. The red and yellow

make those figures clearer and places them in the foreground. The blue tends to push things into the background. This is an important point to remember.

ALWAYS BEGIN BY PAINTING THE SKY

The reason for this rule is that a watercolor is intended to capture a momentary appearance of the landscape. It must be fresh, spontaneous and finished without any touching up. A landscape may include hills, houses and trees which create different planes, and colors which, along with the effects of light and shade, produce different tones. These forms can be painted in sections, by drawing shapes and superimposing and laying colors side by side. But the sky does not contain this diversity of forms and colors. The sky is a whole in itself. Even with the white and grays of the clouds, it has a uniformity of color, a dominant blue, which cannot be produced by small brushstrokes and layers of color. Let me stress this rule: *When painting with watercolor, the sky of a landscape must be produced in its final form first, without the need to go back and touch it up.*

It is not easy to paint a wide expanse of cloudy sky. It requires a great deal of skill. You must know how to put on the water and paint so you avoid breaks and, even more difficult, you must try to get the color right the first time. This is made even more difficult when you realize that the rest of the picture is still white.

When you paint a sky while the rest of the paper is still unpainted, the sky will appear very dark. But when you add color to the remainder of the picture, the sky will appear lighter. It can turn out to be so light that it needs to be repainted! This is an example of the *law of simultaneous contrasts* which states that a gray or blue is stronger in proportion to the lightness of the surrounding tone.

So why not paint the hills and houses first, giving them tone with a first wash, and then paint the sky?

Let me explain. When you have painted the upper part of your picture, you can work and touch up the remainder without having to wait until the sky is completely dry. Despite what I have said about the law of simultaneous contrasts, it is easier to harmonize the entire picture because the sky is usually the largest area and it governs the colors of the remainder.

For this same reason, an oil painter generally begins with the sky. But with oils you can cover underlying colors. Another coat can be painted over the first, lightening or darkening it as required. With watercolors, the sky is done in a few moments, leaving it fresh and spontaneous. If you fail to hit the right color immediately, you have no time to go over it again.

THE FIRST STAGE

On his palette Fresquet mixes a neutral, slightly gray blue, using ultramarine, cobalt blue and a touch of sienna. He also prepares a gray from ultramarine and sienna and another gray which includes a touch of alizarin crimson.

The paper has dried completely.

Fresquet loads his brush with water, takes blue and paints the upper left section. The blue is rather light and not very wet. Immediately he takes up the gray he has mixed and paints below the blue. Where the two colors meet, they blend together. He wipes his brush on the rag and applies it to the lower part of the gray area, soaking up color and lightening it. With a confident stroke of his brush he outlines the silhouette of the roofs.

He now wants a rose-colored shade. He takes a little red and mixes it with the gray on his palette. He gives a touch of it to the area on the horizon. The previous paint is still damp and the rose-gray spreads and blends with it.

At the top, the first light blue is still damp. Fresquet loads his brush with water and darker blue and paints over it. The darker blue spreads to form a patch and goes on spreading as long as it remains wet. Some water has accumulated along its lower edge and when it dries it will form a slightly darker narrow strip. The painting opposite shows the completed forms of the first stage.

But Fresquet sees what is happening to the edge of the blue patch. He takes the blue wash toward the right over the tower, painting this new area on dry paper. He marks out the form of that wide cloud drawn over the tower, letting its whiteness be produced by the dry paper. Fresquet cleans his brush and places a brushstroke of clean water inside the cloud taking the water upward, lightening the sky and shading the existing edge which had formed a break. However, he allows the break to remain on the lower edge of the cloud.

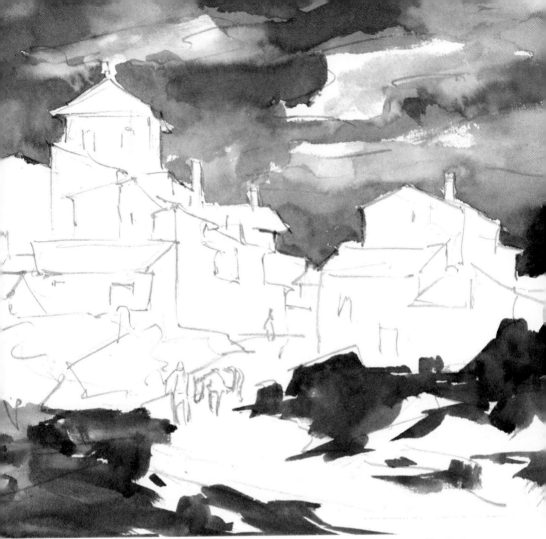

First stage.

Notice how the light blue which forms a break on the lower part of the cloud has blended while wet with the gray of the horizon on the right of the tower. Using the same method as before, Fresquet applies dark blue in a wash which again spreads and blends with the light blue. But now, when it reaches the whiter area of the cloud, it forms a clean line, not touching the white area.

This is the method of dry-brush painting. Fresquet first applies color to dry paper, but then, while it is still wet, quickly paints another color beside it, letting them blend and shade under the effect of the moisture. When he thinks it necessary, he paints on a dry surface, deliberately forming a firm edge. He is in fact using *both* wet-on-wet and dry-brush techniques to produce either blended shapes or firm lines, as he thinks advisable. In practice, this is similar to painting a

monochrome. You accumulate water at one point in order to rework it before it can dry, controlling it at another point in order to outline and paint a firm shape by marking it out.

The dry-brush method calls for even more rapid working than wet-on-wet technique. With the wet-on-wet method the wash must be even and flat, produced by continuous painting which does not allow you to go back over what you have done, but which requires constant wetness. In the dry-brush method you can go back, adding a stronger color, soaking up and so on. Breaks are comparatively important because they are useful in many places. With wet-on-wet, a break may mean that you have to start all over.

Back to Fresquet's work. On the right side of the horizon you will notice a patch of dark green representing some trees behind the houses. See how the edge of these trees is diluted with the grayish color of the sky. This is the result of both colors blending while wet. Note that Fresquet has produced this effect in these trees while firmly indicating the profile of the houses. This is logical: we can assume that these trees are farther away than the houses and form part of the background. So it is quite correct to weaken these outlines to create the sense of space between the planes of the houses and trees. This brings us to the following rule: *When painting dry-brush watercolors, the outlines of more distant objects must be formed by the wet method to produce the effect of distance and intervening atmosphere.*

To complete the first stage, Fresquet paints the greens and siennas of the earth with the dry-brush technique, but still uses the wet-on-wet method at various points.

THE SECOND STAGE

Study the painting opposite carefully. It shows a basic characteristic of the watercolors. When the sky is finished, the artist turns to the darker parts of the subject and paints the strong colors, leaving out the medium and light shades. This is so important that it must be emphasized.

The technique of dry watercolors is characterized by the fact that *after the sky, the darker areas of the subject, dark shadows and strong colors are painted next, leaving out the white highlights.*

This creates dramatic effects and it is easy to paint in this way, drawing, outlining and filling in the volume of objects. And you are

able to go back and touch up with a new wash if necessary, strengthening or giving tone to the colors.

Dry-brush watercolor is especially suitable for painting subjects or models which offer wide contrasts, such as a landscape in strong sunlight.

But notice how carefully Fresquet has marked out the forms which will be painted with medium or light colors. Look, for example, at the small figure in the background or the chimneys.

Notice too, how Fresquet has painted the roofs, each having the original color of the subject. He has not mass produced them in just one color as an inexperienced painter might. He has reproduced the

Second stage.

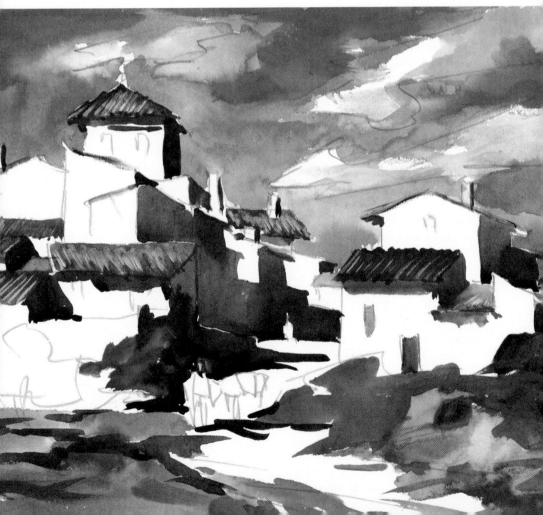

shapes of the roofs by means of light lines or strokes with the tip of his brush handle, as we explained earlier.

THE LAST STAGE

At this point, Fresquet first paints the lighter areas, the broad color washes which correspond to the large, more illuminated areas, such as the light road and the creamy-yellow which lights most of the houses. Fresquet paints these light areas with long brushstrokes without bothering too much whether they go over the outlines.

When he comes to areas which may have to be painted a darker color later, for instance the walls and earth on the left where he will later paint two or three trees, he paints them entirely in the light color. Fresquet takes extreme care not to allow these light washes to intrude on the dark colors of the shadows he has already painted. These dark colors are dry by this time. If these very wet washes touched them, they would produce patches and bad coloring. The same applies to occasional strokes with a brush loaded with water or light washes. These can cause obvious unwanted patches similar to those produced intentionally by soaking up.

In these light colors, and in fact in all the colors, Fresquet is careful to use color differentiation to enrich the picture. Study the areas of color forming the sunlit walls and see how there is a yellow tinge in some and a rose tone in others. There are even slight differences in shade in each surface, subtle but obvious touches of color which animate and heighten the picture. Notice, for instance, the number of fine shades obtained in the luminous coloring of the road.

Fresquet continues by painting the intermediate tones such as the sienna on the front wall of the house on the right. Here, and on some of the other houses, he applies these intermediate colors while the previous light color is still wet. The trees on the left, almost in the foreground, are painted entirely with the wet-on-wet method. First a light green is applied and then, while it is still wet, the darker green for the areas in shadow is added.

Next he paints the figures, doors and windows, and the horizontal shadows in the foreground which are produced with thick, rapid strokes.

The finishing touches consist of balancing some values, strengthening colors at some points and soaking up and weakening others. For instance, look at that vertical light strip in the shadow of the houses along the street, just above the man and donkey in the painting on pages 86 and 87. Compare it with the same area in the painting on page 83. You can see in the first one that Fresquet did not allow for the contrast needed to form a space between the nearest house and the more distant one. Fresquet solved the problem quite easily by removing color with his wet brush.

Finally, Fresquet paints small white lines with the end of his brush and his fingernail, and makes the strokes on the grass in the foreground using his brush. The thick yellow lines on the right edge of the road are made with his fingernail. So are the two small vertical lines representing windows in the shadowed houses along the street.

To sum up the dry-brush watercolor method, these are the points to remember:

● Paint and finish the sky first.

● Use the dry-brush technique to paint the darker areas such as shadows and strong colors, leaving out the white highlights.

● Wait until the entire picture is dry and color the lighter areas, representing the more luminous parts.

● Use the dry-brush or wet-on-wet techniques to paint the intermediate tones and colors, whichever is most suitable.

● Paint small dark details almost last.

● Balance tones and colors by strengthening or soaking up paint. Make any small white lines and add the finishing touches.

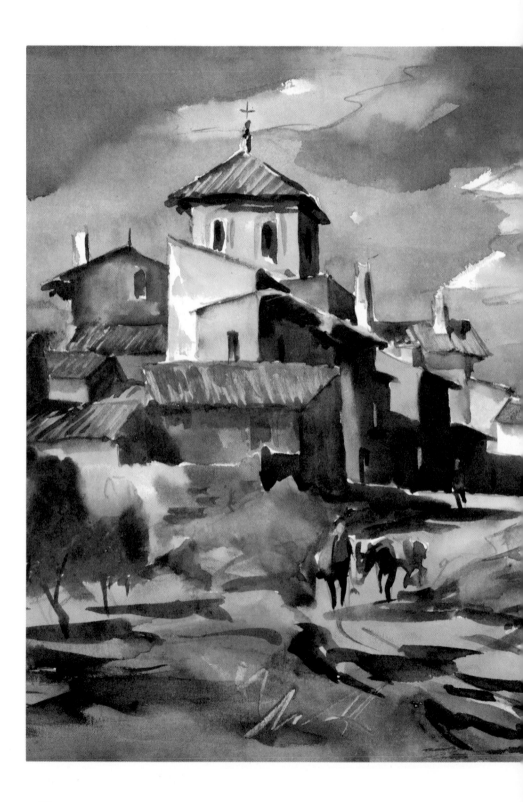

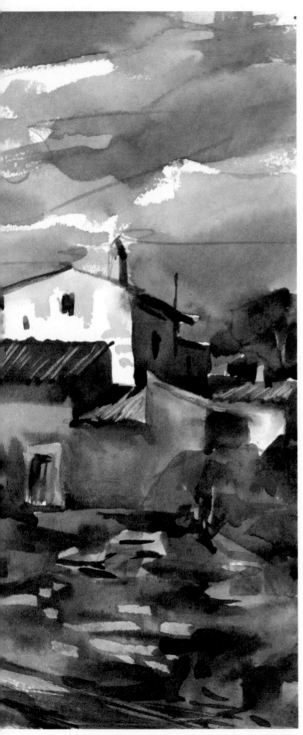

The final result obtained by Fresquet using the dry-brush technique.

THE WET-ON-WET METHOD

Now we come to another landscape. It is a cloudy day, one of those afternoons following a rainy morning when the ground and fields are still wet, but the sun suddenly breaks through the clouds and creates a wonderful symphony of light and color. Look at the finished work on pages 94 and 95. This time I want you to paint with Fresquet.

MATERIALS	
Alizarin crimson	No. 10 brush
Cadmium yellow	No. 6 brush
Ultramarine blue	No. 2 brush
Black	Rag
Drawing board	Scrap paper
Paper	HB or B pencil
Water	

FIRST THE SKY . . . AND IN THIS CASE THE TREETOPS

As before, you must first wet the paper to ensure that the surface is completely clean. Then sketch in the subject with a few lines, just enough to place the objects. In this scene that empty space between us and the nearest trees does not conform to the standard idea of a foreground. But notice the unity and order produced by the diagonal composition and the effect caused by the oblique line of perspective formed by the road and the line of trees. It is an unusual composition, but one that could be very pleasing.

FIRST STAGE

The first step in the wet-on-wet method is to *wet the paper with a thick brush so that you will paint on a wet surface.*

It should not be too wet. Wait until the water has soaked into the fiber of the paper. This moisture will be retained for some time, long enough to renew it with several washes of color. If you hold the paper at an angle so that the light shines along it, the water should not shine.

As you apply this first wash of clean water, be particularly careful to leave out the white areas formed by the tree trunks and the lower section corresponding to the foreground and middle plane.

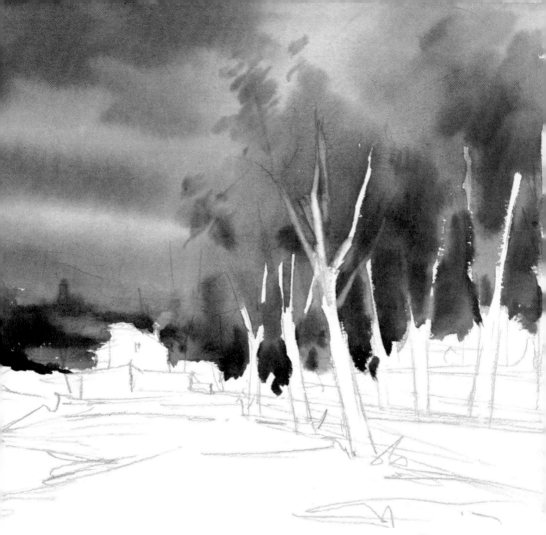

First stage.

Notice how Fresquet has fixed the horizontal line forming the boundary of the green field behind the shed nearer and lower than the actual horizon. He does this so the real horizon and far distance can be blurred with the wet-on-wet technique. The contours will be diffused, creating a greater sense of distance and depth. The far distance must always be diffused to contrast with the solid forms in the middle and foreground.

On the right he makes a break above the horizon, forming the lower edge of the tree foliage. This is closer to our viewpoint and can be made more concrete.

Start your painting at the upper left corner of the sky, applying a light warm gray to the wet surface. Spread this first gray toward the

right, diluting it with more water as it approaches the treetops. Work this area with your brush, shading in the center with clean water. Spread this light gray downward until it comes close to the real horizon. Then add a very small amount of alizarin crimson. Return to the upper left section and apply a slightly rose-colored light gray.

Next mix a darker gray and paint the large threatening dark clouds with wide brushstrokes. Aided by the moisture, the color will spread smoothly and evenly. You can help by soaking up the color wherever it accumulates and adding color where necessary in very light touches.

Now move to that little hill with the castle. Use ultramarine blue, sienna and alizarin crimson. Soak up color from the upper section and add brown with a stronger red tinge until you get just the color you want.

Keep moving quickly. Mix the ochre for the trees from sienna and a little green, neutralizing it with red when you want a rose-tinted ochre, or with ultramarine blue when you paint the greens with a khaki tint. Apply the same range of color to the trees on the left up to the horizon.

When you realize that a break might occur because of dryness, add clean water, but only enough to blend the colors.

I have stressed painting dark tones on light colors, and this is the method we are following here. For instance, in the large area of foliage on the right, begin by painting with the lighter rose-tinted ochre, then add darker washes and colors until you obtain the result shown on page 89.

THE SECOND STAGE

Using the same method as before, turn to the ground and fields, and the gray strip of road. Again, begin by wetting the paper with clean water, leaving out the whole shed, the area forming the river, and the tree trunks.

Notice how some colors have been blended with others in the land and fields so that it is possible to correct, remove and add colors while the paper remains wet. The result should look like the painting opposite.

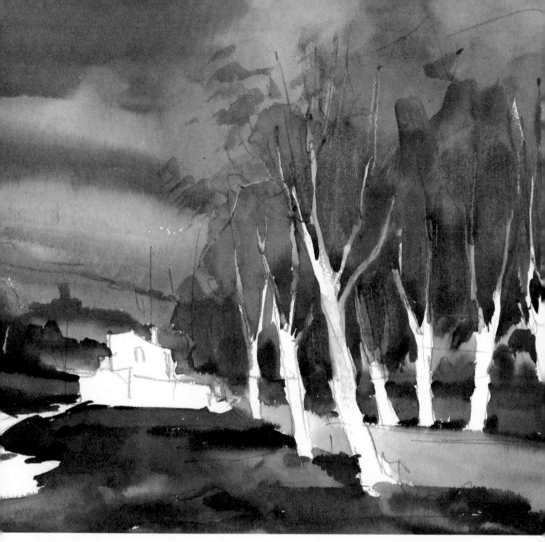

Second stage.

THE THIRD AND LAST STAGE

We have now come to a special problem, how to paint water and its reflections. These instructions can cover more specific and wider applications, for instance harbor scenes with boats at anchor.

HOW TO PAINT WATER AND ITS REFLECTIONS

First apply a transparent wash reflecting the color of the sky.

If the subject requires it, leave out a brilliant, completely white area. In nature these areas are only produced when the sunlight

reflects brilliant white spots on the water along your line of vision. We don't see this often because it is not advisable to paint with such bright conditions. However, these pure white areas can be produced by reflections of white boats in slanted sunlight.

While the first light wash reflecting the sky is still wet, Fresquet adds the dark tones of the forms reflected in the water. When painting these tones, he reproduces the concrete forms in the model. If he wants to add white areas which he has been unable to leave out in advance he can soak up color leaving almost pure white areas. I advise you to use both methods. Mark out the obvious white highlight areas in advance, and soak up color with your brush to reveal other highlights and light areas after painting. This way you will get a less clear cut and more realistic finish.

In the water shown in our landscape, the white reflection of the horizontal strip was obtained by soaking up color with the brush.

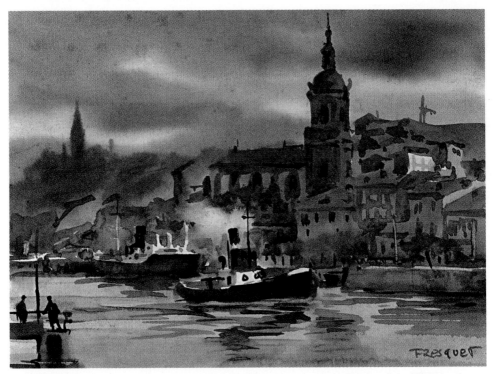

The reflections in this watercolor by Fresquet were obtained by the techniques described above. A combination of wet painting and dry-brush techniques were used. No pure whites were left in the reflection.

FINISHING TOUCHES

With the water in the stream completed satisfactorily, the only problem remaining is deciding what final touches are needed to enrich the colors already applied in the second stage on page 91. The tree trunks and varied shapes of the shed must also be painted.

To make the tree trunks appear farther away, paint a wash of dirty cream on them. Then you can produce their cylindrical form by applying burnt gray. In our painting, Fresquet let white paper show through on the two nearest trunks to form highlights.

Vertical lines, such as the thin branches on the nearest trees, are made by scratching the paper with the tip of a brush handle.

To finish the closest areas of the ground, try this method which is very similar to dry-brush technique. Begin by wetting the areas with clean water, but without rubbing or scraping with your brush. When the areas are almost completely dry, paint over them with darker colors.

Use the dry-brush method to paint the overall light tones of the shed. Bring out the volume of the shed by applying the dark tone while the previous washes are wet. Fresquet felt it necessary to paint around those thin strips of white on the left face of the shed because they give the building greater volume and distinguish it more clearly from the background with its blended values.

Finally, painting with a dry-brush, mark the very small shapes such as the thin tree trunks, the shadows of the trees on the road, the blades of grass and lines or strips separating the fields. If you apply too dark a tone, whether intentionally or not, simply run your finger over it to remove some of the color and produce the required tone.

All that remains is to balance some of the colors by adding or removing them, and to reveal white areas with your fingernail or brush handle, and the painting is finished.

Here's a point well worth remembering: It often is the finishing touches added to an otherwise well-painted landscape that turn it into an exceptional creation.

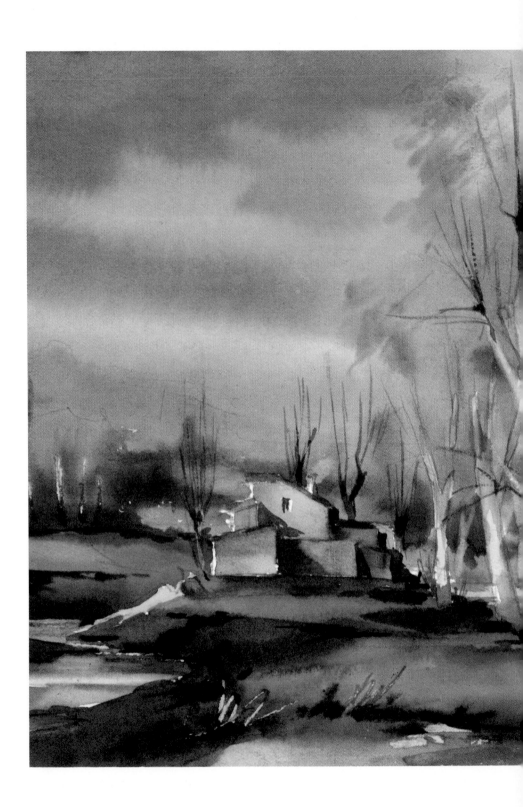

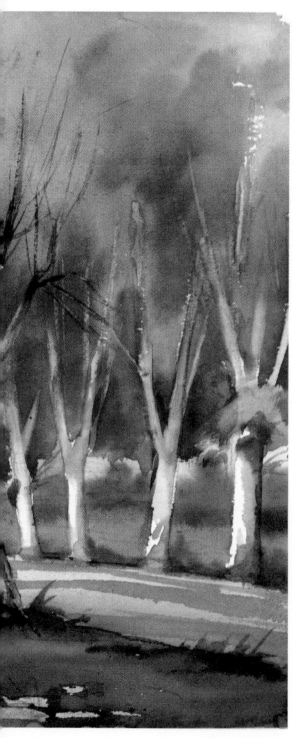

This is the final watercolor created by Fresquet.

6 A COMPLETE WATERCOLOR

Sketching
Repainting Sky
Using India Ink

Now for the final test: Using every color, you are going to paint Fresquet's watercolor *Barcelona Port.*

To help you, the first and second stages of this painting appear on pages 100-101 and 106-107, so that you can see more easily and clearly how it developed. Study these pictures, noting the techniques employed by Fresquet. The finished work appears on pages 110-111.

Besides gaining practical experience in composition, technique and coloring, this exercise gives you an opportunity to follow the path of an expert, to see and listen to his advice almost as if he were beside you, guiding your hand.

Bear in mind that this is an essential step toward working on your own.

MATERIALS

Lemon yellow	Drawing board
Golden yellow	Paper
Yellow ochre	Water
Burnt sienna	No. 10 brush
Vermilion	No. 6 brush
Alizarin crimson	No. 2 brush
Viridian	Rag
Cobalt blue	Scrap paper
Ultramarine blue	HB or B pencil
Black	

GENERAL INSTRUCTIONS

Make all your preparations with great care. Don't forget any materials or equipment. Work with a wooden board or a panel which is large enough to hold the paper easily. Fix it with plenty of pins to prevent wrinkles caused by the moisture. Have two jars ready and

filled with plenty of water. Find a piece of smooth rag which will absorb the water and color from the brushes when you use it for drying.

Ideally, the final work on pages 110 and 111 should be set in front or beside you so you can see it easily.

To study the way the colors are applied, examine all the stages of the painting reproduced in this book.

This exercise can be done either in daylight or artificial light. But, we recommend you work in daylight. You will gain a better appreciation of the colors.

PRELIMINARY SKETCH

The figure on page 98 shows a reduced version of the original pencil sketch which Fresquet did as part of this composition stage. Look at this drawing. Notice how it is built up from clear, unfussy lines without resorting to two or three lines where one will do. You must try to work like this. You will learn to draw by drawing, so give it a try.

In this first stage we can make an accurate copy of Fresquet's painting. This drawing must be an identical and precise reproduction of each area, line and plane. You will realize that in his drawing Fresquet does not include every detail of the original subject. Professionals sketch the forms with only enough detail so they can finish and adapt them as they paint. You need to work spontaneously from the very beginning and not bother with minor touches. But be careful. At this stage, your exercise must be precise in composition, position and proportions.

Even when the basic drawing is finished, you can still adjust part of the sketch by adding more detailed items from the finished work such as the cranes which appear above the buildings on the left, or angles and profiles of those buildings or others.

FIRST STAGE

Before going any further, you must decide which method is to be used for this watercolor. The dry-brush or the wet-on-wet technique.

In this case, you will use both techniques. You can see this for yourself if you carefully study the finished painting. The sky and some of the shapes in the background have been painted with the wet-on-wet method. The sheds and their roofs, the vehicles and figures and the network of cranes have been painted with the dry-brush technique, producing firm outlines despite the subtle contrast caused by similarity in tones and colors.

Begin with the sky. This is all the more important when you realize the role the sky plays in this picture.

THE COLORS

In this painting the dominant color is sienna-blue. If you mix ultramarine or cobalt blue, burnt sienna and some water, you will get a color which is very similar to many of the painted areas of this picture. This color ranges from a neutral gray to a warm or cold gray, a dirty blue or a grayish sienna, depending on the amount of each color used in the mixing. Finally, by mixing both colors with a little water, you will get a dark sienna similar to that used by Fresquet for painting

98

figures and dark shadows or forms. You can test this by using a scrap of paper. As you go through the instructions, you should test all colors before using them.

Before you start to paint, wet your paper with a brush and clean water. Moisten the paper down to the limit marked with the thick line shown in the figure below. This will enable you to blend the outlines which border the sky, as we shall see.

When following these instructions, look at the drawing on page 102 where the sections or zones mentioned in the text are indicated by A, B and C.

Working on wet paper is extremely important. In the center of the area of the sky marked A, apply a load of mainly ochre color, mixed with a little cobalt blue and a very small amount of red. Be careful with the red! It is very strong and can easily dominate the mixture. Remember, ochre is the dominant color you want. When this mixture is applied, the water will dilute it, spreading the color up to the edge of area A. Help it spread with your brush to produce shading. This ochre is gradually diluted outward from the line.

Now move to the left and center of the sky, marked B, and paint with a mixture of cobalt blue and sienna. This color is the dominant

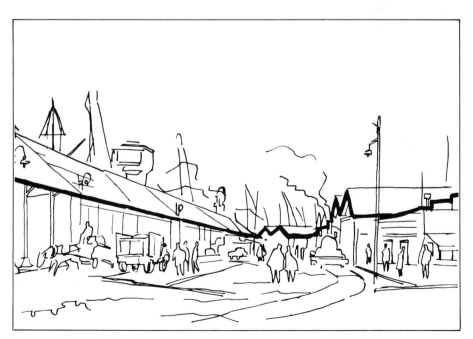

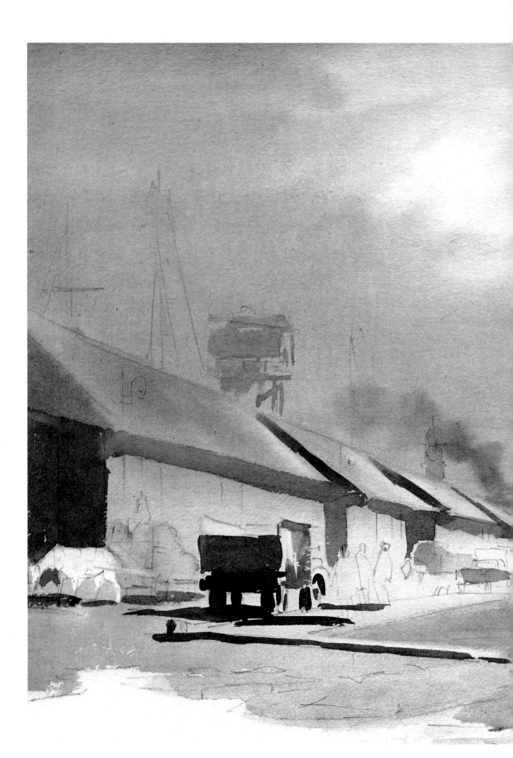

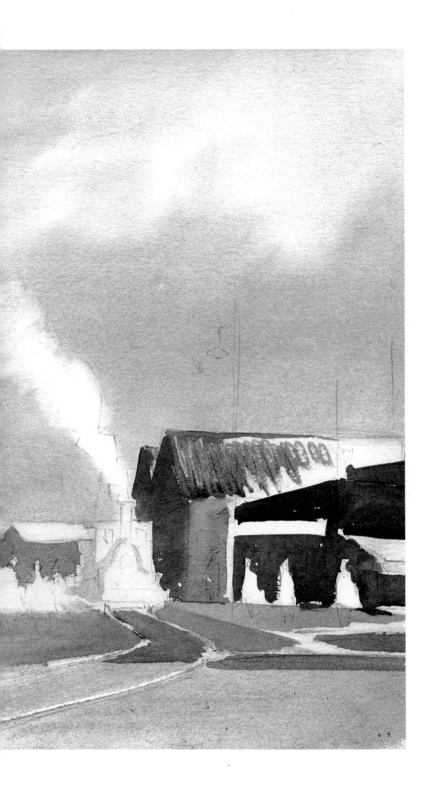

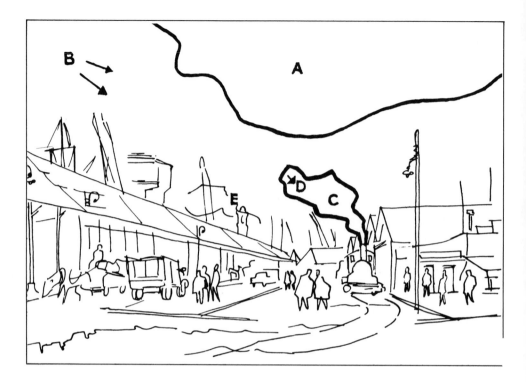

color of the whole sky, so mix enough. Spread this blue-sienna from B, blending it with the ochre when it reaches area A.

The surface must still be slightly wet as you mix more of this blue and sienna color. Add almost imperceptible shades of rose, rose-tinted alizarin crimson and very light green so that the background of the sky is not completely flat. It should contain variations which enrich the general coloring.

When you reach the smoke from the train, first mark out a white area as shown by C. Try to form a break where the edge of this white area approaches the funnel. Then, with your brush and clean water, blend the blue-sienna at D with the white of the smoke until the smoke is shaded into the sky.

Still working on a wet surface, use a brush loaded with a mixture of ultramarine blue, sienna and a little water to paint in the gray smoke over the roof, E. Allow the wet surface of the sky to merge with this darker tone.

As you can see in the drawing on the next page, there are two lines along the lower edge of the sky. The thick line, A, is the edge of

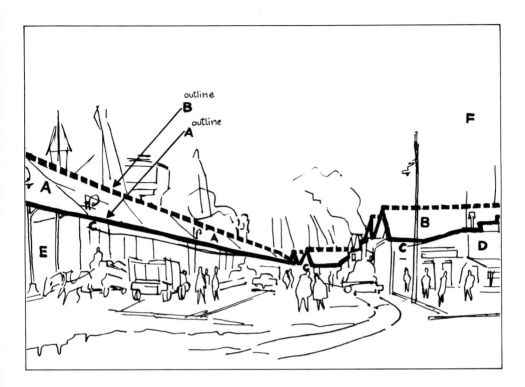

the area first moistened with clean water. The dotted line, B, is the edge of the blue-sienna of the sky. The blue-sienna has to be brought down to line B and shaded and blended so that at A the color has faded out. Try to avoid an abrupt break.

Notice that this area along the horizon, particularly in the center, contains a more obvious mixture of rose-ochre in the blue-sienna which is also slightly lighter.

Complete the sky on the right side, marked F, with cobalt blue and sienna as dominant colors.

The sky contains no marked out white area except the smoke from the engine.

Both the complex of cranes and the electric lamp post on the right should be painted on the blue-sienna of the sky without making out any separate area in advance.

That completes the sky. How did it go? As you know, it has to be left as it is or be done all over again. However, if it has to be redone, here is a trick that can help you.

HOW TO REPAINT A SKY WITHOUT STARTING ON A NEW SHEET OF PAPER

Imagine that the sky has not come out right the first time, and that it contains breaks, beads, unevenness and other imperfections. And suppose that you don't want to begin all over again.

Place the paper in a tub or sink filled with clean water if you are working at home, or in a pond or river if you are working in the country. Let the water cover the area on which you painted the sky. Dry and wipe it with a rag. Repeat this until the water has diluted the washes of the sky and it is clear enough to paint again.

This method is not always effective. It is no good if the sky contains a lot of color or if, in order to dilute the color, you make the paper so wet it wrinkles. But it works well enough in most cases. Let's go back to our painting.

To paint the roofs on the left, marked A, begin by wetting this area with clean water. Then apply a mix of ochre and sienna with a touch of ultramarine blue. Use very little blue, just enough to make the original ochre-sienna mixture gray.

The basic colors of the roofs on the right, B, are ultramarine blue and sienna with the blue dominant. But you may need a very small amount of black and an even smaller amount of green. Test before you apply it.

For the shadows cast by the roofs, C, you must obtain a grayish purple with a tinge of sienna by mixing ultramarine blue and a little alizarin crimson.

Now move to the ground. First paint a very pale wash mixed from ultramarine blue, ochre and burnt sienna, producing a rather dirty cream. Add a touch of green, sienna and ultramarine blue on the left. Continue with this color up to the right foreground, introducing some ochre and an extremely small amount of red, just enough to give it a slight rose tinge. Finish the most distant areas using a little more sienna and a little green. If necessary, make it grayer by adding ultramarine blue. Be sure you leave out the white areas shown in the model when painting the ground.

Paint the walls of the bar on the right, marked D, with a mixture of sienna, ultramarine blue and green.

Paint the open shed on left, marked E, with a mixture of sienna, ultramarine blue and green. Make sure you leave out the shape of the horse.

The truck has a dominant green made gray by adding sienna. The bales on the wagon pulled by the horse are ochre with a touch of blue, just enough to mute the strident yellow of the ochre.

THE SECOND STAGE

Look on pages 106-107 and notice how this stage is produced. The colors that you have already mixed for the first stage are almost sufficient. Of course, these mixtures have already shown you which colors play the fundamental part in the artistic unity of this water-color, namely cobalt or ultramarine blue. Bear in mind here that while cobalt blue is a neutral blue, ultramarine always has a violet tinge. Both these blues are almost always mixed with burnt sienna which is the basic color used to obtain that bluish gray of the sky. And burnt sienna is dominant in the figures and objects in the remainder of the picture. Ochre and green also occur in some of these objects. Ochre introduces a yellow tinge and green enriches the mixture. Finally, minimal amounts of alizarin crimson are used to give a slightly warm feeling in some of the shades. As a last resort, black can be introduced to provide some clean grays.

Paint the masts and cranes using ultramarine blue and sienna with a very light wash of rose-alizarin crimson. This will produce a slight violet tinge, but only use a very light wash.

Add the figures in the foreground with sienna, blue and green and paint the side and engine of the truck with ultramarine blue and alizarin crimson. When painting this blue side and the reddish alizarin crimson of the engine remember that you don't have to be neat. A very small amount of sienna has to be added to the blue to mute it, and a touch of gray (black or light blue) is added to the alizarin crimson for the same purpose.

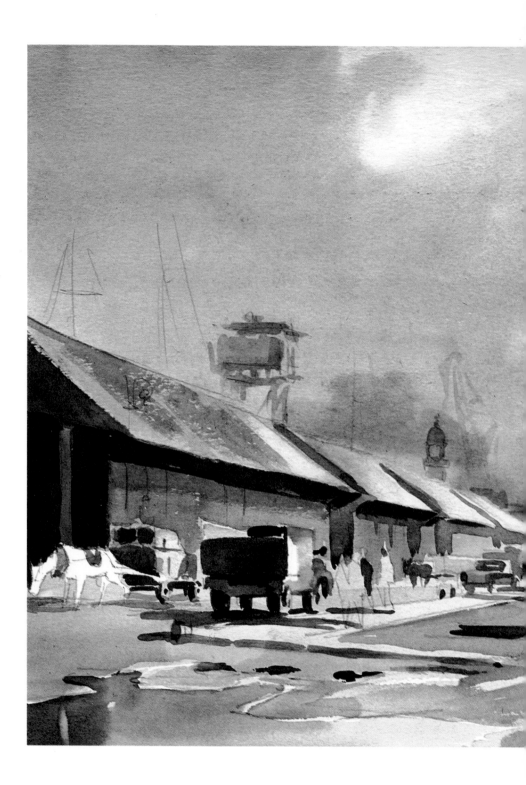

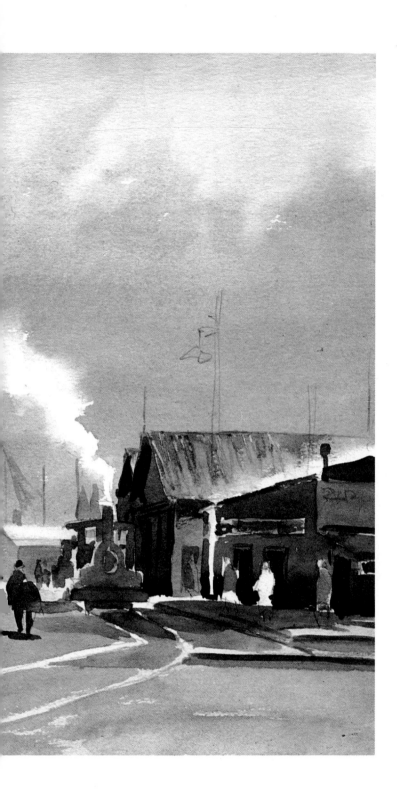

THE LAST STAGE

We are not going to talk about colors any more. I feel sure that you need no more advice in this respect. Instead, I will mention a few points called for in this last stage.

To paint the puddle in the foreground, use the method we used for the water in our previous exercise. First, apply a wash of light color reflecting the color of the sky. Then, while it is still wet, add the dark colors reflecting objects and shadows. In this case use sienna, green and ultramarine blue, bringing out the highlights, forms and reflections by soaking up color with your brush.

As you can see by comparing the illustrations of the previous stages, in the finished work the ground has been painted in two or three successive washes. Notice that the dark areas, corresponding to the shadows, have been painted with the dry-brush technique.

The lower part of the lamp on the right was marked out at the beginning. But, as you may have noticed, this marked out area may become covered. If so, simply paint the shape of the post with the dark gray and then lighten the lower half with a dry brush, soaking up the tone and color.

DRAWING FINAL TOUCHES WITH WEAKENED INDIA INK

If you carefully study Fresquet's finished watercolor on pages 110-111, you can see some thick, solid almost black lines here and there. Examples are the curve of the tracks of the approaching train, the outlines of the roofs on the left or the leg and hooves of the horse. These lines are part of the technique for finishing off this type of clear cut watercolor, by strengthening the outlines and profiles of certain shapes. They are usually drawn in India ink, using the sharpened end of a brush handle. The ink is diluted with water so that the lines are not too strong. You can keep a jar of India ink wash made up for adding these effects.

The sharpened brush handle is ideal for producing a full dark line. A broken, wide line can be made by drawing with the handle almost dry, as shown in the wires running from the right post in Fresquet's drawing.

SIGNING AND FIXING

Signing a finished painting is just as important as the design of the painting itself. The signature should not be so obvious that it is the most important element. I know you are proud of your work of art, but allow your audience to view your painting first and notice the name last.

What does fixing mean? Even first-class watercolors lose a little of their intensity when they dry. This is painfully obvious with low quality colors. To reduce this loss of color, you can buy a *watercolor fixative*. Simply spray your dry painting with a light wash of this fixative and your colors will be preserved.

AND THAT WAS PAINTING IN WATERCOLORS

To be successful, you must have both the artist's temperament and the laborer's dexterity. You cannot paint well without discipline and without learning the rules. With oils, you can leave a picture and return to it later. Bad work can be corrected at a later session when you are calm and collected. But this is impossible with watercolors. You must accept its rules and exacting laws.

The English watercolorist Bacon once said, "You only master watercolors by obeying their laws."

Yet, mastery of this art reveals unsuspected avenues for learning more about drawing and painting.

You've finished your first works in watercolor. I hope there will be many more.

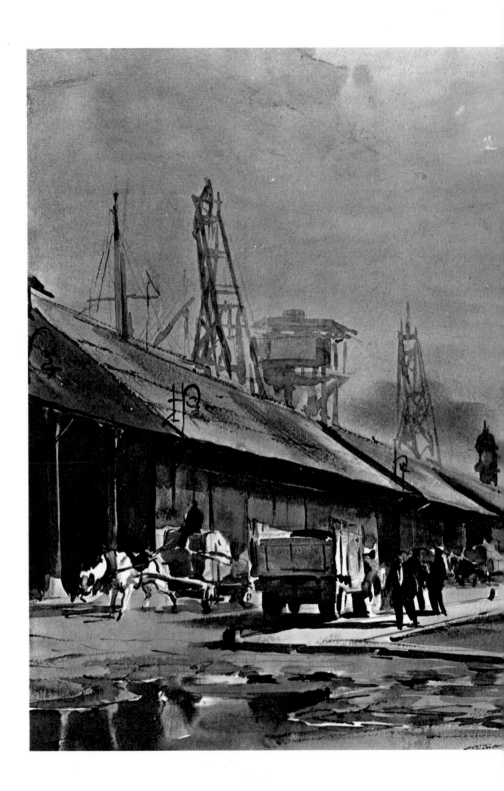

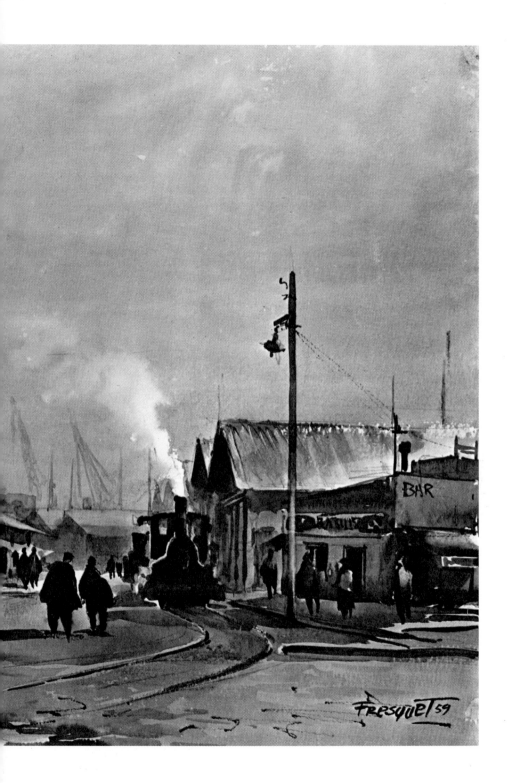